WEAVING
Is Life

Navajo Weavings
from the Edwin L. & Ruth E. Kennedy
Southwest Native American Collection

Edited by Jennifer McLerran

Kennedy Museum of Art
Ohio University
Athens

in association with
University of Washington Press
Seattle and London

Kennedy Museum of Art
Ohio University
Athens, OH 45701
www.ohiou.edu/museum

University of Washington Press
PO Box 50096
Seattle, WA 98145-5096
www.washington.edu/uwpress

Library of Congress
Cataloging-in-Publication Data

Weaving Is life : Navajo weavings from the Edwin L. & Ruth E. Kennedy Southwest Native American Collection / edited by Jennifer McLerran.
p. cm.
Includes bibliographical references.
ISBN-13: 978-0-295-98652-4; ISBN-10: 0-295-98652-2 (pbk. : alk. paper)
1. Navajo women weavers—Exhibitions.
2. Navajo blankets—History—Exhibitions.
3. Navajo textile fabrics—History—Exhibitions.
4. Southwest, New--Social life and customs—Exhibitions.
5. Kennedy Museum of Art—Exhibitions.
I. McLerran, Jennifer. II. Kennedy Museum of Art.
E99.N3W387 2006
746.1'40899726—dc22

2006022527

Printed on acid-free paper

Front cover:
Gloria Jean Begay
Dawn Meets Dusk, 2005
natural (undyed) and aniline-dyed commercial wool
48 x 59 in.
Edwin L. and Ruth E. Kennedy Southwest Native American Collection
Kennedy Museum of Art
Ohio University
KMA 2005.06.01

Back cover:
D. Y. Begay
Journey, 2005
natural (undyed) and vegetal-dyed handspun wool
49 x 35 in.
Collection of the Heard Museum, Phoenix, Arizona

KENNEDY MUSEUM OF ART

OHIO UNIVERSITY

40th ANNIVERSARY
NATIONAL ENDOWMENT FOR THE ARTS
Established 1965

Ohio Arts Council
A STATE AGENCY THAT SUPPORTS PUBLIC PROGRAMS IN THE ARTS

Contents

Foreword

Paul M. Legris
John A. and Dareth B. Gerlach Director
Kennedy Museum of Art

In 1989, I was motivated by a sense of adventure (and lack of money) to seek employment on the far-flung archipelago of the Queen Charlotte Islands, some 90 miles off of the northern coast of British Columbia. The rain was incessant, and the rough seas across the Hecate Strait increased the mainland-to-island ferry voyage from a nauseating four hours to a torturous seven. Nevertheless, the journey was fortuitous. It was not long before I immersed myself in the endless tasks of assisting a young museum director in the operation of a small collection and research facility called the Queen Charlotte Islands Museum (renamed the Haida Gwaii Museum at Qay'llnagaay some years later). The collections were exciting, consisting of ancient and contemporary works of cedar, alder, and argillite. I knew nothing of Haida traditions, language, food or art. Yet, what I came to realize was the pre-eminence of things, which surpassed any sense of time, tradition or history in which I felt connection. Great monuments of cedar from places with such names as Skedans, Tanu, Cumshewa and Skidegate conveyed permanence and assurance for those who created them and for those who continue to create.

Today, as then, it is my contention that the fine art traditions of Native American and First Nations groups represent the highest levels of visual art on this continent. I am always reminded of this when I travel to Arizona and the Four Corners region of the Colorado Plateau, where I experience high desert elevations, zero humidity, sunlight and magnificent Navajo weavings so brilliant, linear and symmetrical. Each layer within a weaving is like a horizon line. Geometric patterns, generations old, are almost visible in the desert landscape. Land and air seem inseparable from the art. As a Navajo artist and museum worker once said to me, "so much happens within the landscape bordered by the San Francisco Peaks and the Grand Canyon."

In my current role as Director of the Kennedy Museum of Art at Ohio University, I feel it is less a responsibility than a great privilege to care for and maintain artworks of such caliber and importance as the Edwin L. and Ruth E. Kennedy Southwest Native American Collection, a unique and culturally significant collection of Navajo weavings and silverwork. Thanks to the generosity of an Ohio University alumnus, the late Edwin L. Kennedy, this spectacular collection represents the museum's greatest treasure. Dr. Jennifer McLerran, Curator with the Kennedy Museum of Art, and Sally Delgado, Curator of Education, have dedicated years to researching,

interpreting and acquiring works for this fine collection and have worked extensively with countless scholars, artists, and tribal representatives fostering national and international prestige for the museum and its collection.

In 2005, the Kennedy Museum of Art opened its semi-permanent exhibition *Weaving Is Life* which features the work of multiple generations of Navajo weavers. Combining works drawn from the Kennedy Museum of Art's existing collection of Southwest Native American textiles with newly commissioned weavings, *Weaving Is Life* includes the work of as many as four generations of weavers from four different families. Weavers represented are Grace Henderson Nez, Mary Henderson Begay, and Gloria Begay from Ganado, Arizona; Glenabah Hardy, Irene Clark, and Teresa Clark from Crystal, New Mexico; Lillian Taylor, Lillie Taylor, Rosie Taylor, Diane Taylor Beall and Amber and Twyla Gene from the Indian Wells, Arizona community; and D. Y. Begay from Tselani, Arizona. Each family is represented in individual galleries with audiovisual experiences carrying interviews and first-person accounts of each weaver and her life experiences. Additionally, the *Weaving Is Life* Education Galleries provide an immersive visitor experience to the area of the country known as *Diné Bikéyah* (Navajo Lands) in both the sound of the Navajo language, and in the words of the weavers represented in this exhibition. The works of these weavers have been beautifully reproduced for this catalogue.

Weaving Is Life provides a wonderful opportunity for the Kennedy Museum of Art to showcase this world-class collection and to foster relations with other institutions having similar missions and collections. Thus, it is a great honor for the Kennedy Museum of Art that we travel *Weaving Is Life* to the Museum of Northern Arizona in Flagstaff in 2007. A venue such as this could not be more appropriate, as the Kennedy Museum of Art's magnificent collection of Navajo weavings will be displayed in close proximity to its place of origin.

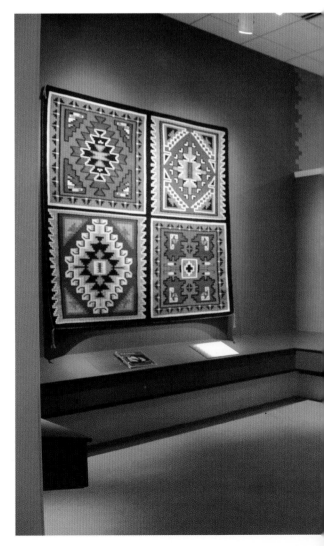

Museums are more than just repositories. They are more than just galleries of novel objects with didactic labeling. Museums are caretakers of objects and ideas considered culturally significant. The Kennedy Museum of Art prides itself in offering interpretive and learning experiences to all of its members, guests and constituents. I am confident that viewers of this beautiful publication will greatly enjoy the magnificent treasure of Navajo weavings from the Edwin L. and Ruth E. Kennedy Southwest Native American Collection.

The Kennedy Museum of Art gratefully acknowledges the support of the National Endowment for the Arts, the Ohio Arts Council, the Ohio University 1804 Fund, the Edwin L. and Ruth E. Kennedy Endowment, Bank One NA, the City of Athens and the Athens County Convention and Visitors Bureau.

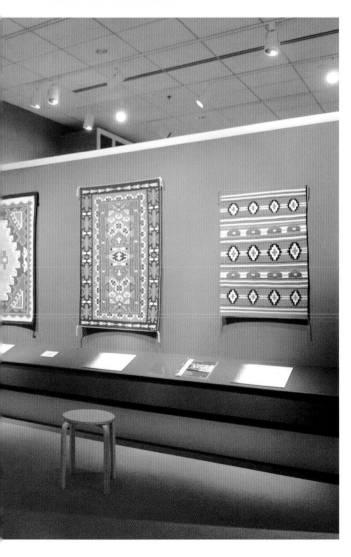

FIGURE 1.2. Installation view, *Weaving Is Life*, Kennedy Museum of Art, Ohio University, 2005.

Textile As Cultural Text: Contemporary Navajo Weaving As Autoethnographic Practice

Jennifer McLerran, Ph.D., Curator, Kennedy Museum of Art

On November 6, 1932, the *New York Times Magazine* featured an article on Native American arts and crafts for home interiors. A photograph of a spacious living room tastefully decorated with Southwest Native American basketry and ceramics arranged around the perimeter of a large, boldly patterned Navajo rug bore the caption "Indian Arts and Crafts for the Modern Home." Readers were told that "American Indian arts and crafts are finding a growing appreciation among home decorators and designers of household furnishings." Such forms, it was reported, "have proved most effective in the decoration of country living rooms, sun-rooms and adult playrooms." In fact, Native American arts had become so integral to modern home decor that they commonly determined the entire decorative scheme of a room: "The color schemes of rugs, baskets and pottery often determine what hue to use on the walls and wood trim and what fabrics to use for window curtains." The reader was advised of the particular utility of Navajo weavings: "In a studio room with light plaster walls, a large Navajo rug in gray, black and white geometrical forms may become a decorative foundation."[1]

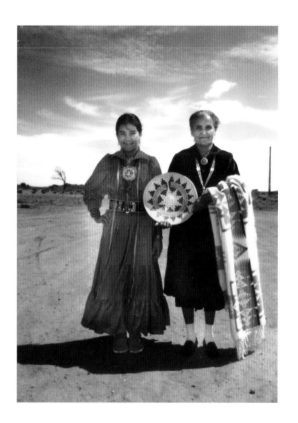

FIGURE 2.1. Lillie Taylor and granddaughter Sherri Gene at Sherri's *Kinaaldá*. Taylor holds a Navajo ceremonial basket, which plays a significant role in a number of traditional practices, including the *Kinaaldá* ceremony that marks a girl's passage to womanhood.

Beginning in the late nineteenth century and extending well into the twentieth century, Navajo weavings found wide popularity as rugs for Euro-American homes. As floor coverings, they primarily fulfilled a decorative function, providing evidence of the homemaker's good taste. However, they played another role in the domestic environment, serving to demonstrate the enlightened consciousness of the consumer. Through patronage and display of a form that demonstrated the native woman's capacity to assimilate to a white economy and culture, the non-Native homemaker proffered evidence of the superiority of her own culture. Additionally, through the display of native women's craft, she demonstrated the presumed universality of such properly "feminine" domestic pursuits.[2]

Navajo weaving varied to suit shifting Euro-American tastes. An expanded color palette developed in some periods, while at other times a more limited palette prevailed.[3] Experimentation with new materials and marketing strategies was constant. But throughout these many changes, Navajo weaving has remained an important form of cultural production that has retained meanings and values that work not only to maintain the practice itself but also to sustain its culture of origin. Not the least of the values it propagates is a particular regard of womanhood and properly feminine pursuits that is specific to Navajo culture. While Navajo weaving may have

served to bolster Euro-American gender constructs, it has worked to reinforce Navajo conceptions of gender in quite different ways.

Within the context of traditional Navajo culture, the practice of weaving demonstrates personal and social values and plays a vital role in shaping self and group identities. Weaving is an activity that reinforces traditional gender constructs in Navajo culture by providing the opportunity for performance of behaviors deemed properly feminine.[4] It also contributes to the construction of ethnic identity, allowing the weaver to demonstrate her cultural knowledge and her privileged position as inheritor of a tradition passed down through successive generations. While it offers the opportunity to demonstrate cultural continuity and group identity, weaving also demonstrates the practitioner's individual autonomy. Certain constants in technique and practice have been maintained over time, but high value has been placed on the formulation of unique and creative solutions to the problems that each new weaving presents. Weaving is seen as the opportunity to make individual decisions as well as to develop one's skill and hone one's thinking, to discipline one's thought processes and to practice self-control, patience, and tenacity.

Navajo weavers commonly express how the process itself serves as an analogue to the thought process. In Navajo weaver Irene Clark's words, "Weaving is your thinking. It really makes you think. When you're doing your designing, the

process makes you think, and it teaches you. . . . Our designs are our thinking."[5] The "spirit line" or *tjontii* ("the way out") the faintly perceptible woven line leading from the interior of a weaving to its edge, is perhaps the most obvious visual expression of the way in which weaving is seen to approximate thought.[6] Navajo weavers express the spirit line's function in varied ways, but a constant in their explanations is that the line is liberatory of mind or spirit. As master Two Grey Hills weaver Julia Jumbo explains it, inclusion of such a line in the last few inches of her weavings frees her from the mental task of completing the current weaving and enables her mind to occupy itself with the next piece.[7]

As Clark and Jumbo's statements attest, Navajo weavers see their practice as a reflection of the thought process itself. While it carries personal value and significance to the artist, informing the way she sees the world and how she extracts meaning from it, weaving also functions on the level of communication. A traditional Navajo, as opposed to a non-Native viewer, will more likely understand the complex levels of meaning that inform the weaver's work. As an important form of visual expression, Navajo weaving participates in the production of meaning within a culturally specific semiotic system. However, as an art form that is purchased, traded, and collected by non-Native consumers, Navajo weaving also participates in the production of meaning within a non-Native semiotic system. As an important cultural form productive of quite different—yet mutually

interflected—meanings within both native and non-Native cultures, Navajo weaving provides a cogent example of what art historian Ruth Phillips labels "dual signification."[8] As key participants in a transcultural process of meaning production, Navajo weavers create works that carry meaning in both native and non-Native worlds. Their art relies on dual signification to communicate these divergent meanings. Native makers of commodified forms of traditional arts must draw on the artistic conventions that constitute the consumers' signifying system while, at the same time, they incorporate design elements that have their fullest meaning within their culture of origin.

The individual weaving functions like a text, and its constituent parts—the materials of which it is constructed, the colors and designs that form its visual characteristics—function like parts of a language. There is a vocabulary, a grammar and syntax to any visual art form. When understood, the complex variations and combinations of such elements of visual language can communicate culturally specific beliefs. Further, when the art of one culture enters another as a marketable commodity, the language changes and new meaning accrues. In its new context, the art commodity is often valued for entirely different reasons than it is in its culture of origin. The particular configurations the designs and materials assume under the Navajo weaver's hands have highly

personal meanings, yet they also function as carriers of cultural belief, as signifiers of cultural history and cultural identity. In the act of weaving, the weaver speaks a language that constructs her as a traditional Navajo woman and, at the same time, as a free and autonomous modern subject. Through her actions, she performs according to her culture's social expectations. She shows her acceptance of and her desire to perpetuate those activities proper to the roles of wife, mother, daughter, and granddaughter. Through the use of traditional materials and techniques and the ever-innovative use of a lexicon of design elements that in themselves carry complex constellations of meaning accrued through centuries of use, she further demonstrates recognition of her vital role in an intercultural system of exchange.

Navajo weavings carry personal meanings that are not always apparent to the viewer. Designs, colors, and the very fibers themselves carry rich layers of meaning. This is not to assert, as some have, that particular designs carry common meaning for all Navajos. Rather, designs employed by Navajo weavers carry distinct personal meanings. Navajo weavers' personal stories regarding what we may commonly regard as mundane aspects of their work—the wool and the sheep from which it derives, the natural dyes and the gathering of those dyes, the painstaking, repetitive process of weaving itself—reflect important cultural values and collective histories. And, due to their accustomed usage and the status it confers, particular forms such as the Chief Blanket or ceremonial manta carry significant meaning as well. Greater familiarity with some of these aspects of Navajo weaving allows the viewer to appreciate the rich layers of meaning and history that underlie this practice. By combining close visual readings of individual works with the personal reflections and stories of weavers, we can achieve a greater appreciation of these meanings. Thus informed, we can approach an understanding of how these works function as important carriers of personal expression and cultural values. Thread count and conformance to the dictates of particular regional styles become less important, and an understanding of Navajo weaving that more closely approximates that of the weaver herself results.

As contemporary weaver D. Y. Begay explains, "Weaving is communication. It is like speaking Navajo. It enables me to communicate with weavers, my family, and my friends."[9] Navajo weaving functions like a language, with codes and conventions that carry complex layers of meaning. These meanings are embedded in specific historical, cultural, and familial contexts. An awareness of these contexts of meaning enhances the viewers' understanding of the work and allows a greater appreciation of the individual choices that the weaver has made in its production. The uninformed viewer may regard a weaver's use of a particular vegetal dye as a simple reflection of the maker's color preference or design sense. However,

when the viewer becomes familiar with the weaver's history, she can appreciate the complex and highly significant cultural factors that informed such decisions. A particular dye plant may have been chosen because it also serves as a medicinal source or because the weaver was originally introduced to it by an honored family or community member. Similarly, a design may be perpetuated as a way of honoring one's mother or grandmother or because it references an animal or a plant important in traditional ceremonial practice.

Delving deeper into the choices a Navajo weaver makes in her practice reveals how, in the act of weaving itself, the artist participates in the perpetuation of a particular ethics of being and a regard of her own and others' proper place in the world. Her actions express and fulfill an individual responsibility to contribute to the continued order and vitality of her family, her culture and her environment. As Begay explains,

> Weaving is not just a matter of sitting at a loom and weaving; it is not only about weaving techniques and rug designs. My weaving reflects who I am. It incorporates my beliefs, my family, and my community.[10]

The Contemporary Trading Post and the Performance of Ethnicity: The Work Display

Historically, the trading post has served as an important site of development and economic exchange for Navajo weaving, and the contemporary trading post shares in this history. However, as the present vestige of an economic system that has become largely unprofitable, the contemporary trading post no longer serves as a primary conduit for the trading and selling of native arts. Today, it more typically functions as a convenience store for the Navajo and as a historic site for tourists. The contemporary trading post that has become the most viable as a tourist attraction is the Hubbell Trading Post National Historic Site.

Located at Ganado, Arizona, in the southeastern region of the Navajo Nation, the Hubbell Trading Post is the longest continuously operating post on the reservation. Purchased in 1878 by Juan Lorenzo Hubbell, it was run by the Hubbell family until 1967 when it was declared a National Historic Site and came under National Park Service Management. Since its purchase by the Park Service, it has continued to function as a trading post and has continued as an important outlet for the trade and purchase of Navajo weavings. Selling the work of many top weavers, as well as their lesser known counterparts, the Hubbell Trading Post is also the site of the Hubbell archive and museum, which

holds the post's business records, an invaluable collection of weaver interviews, and an important collection of historic Navajo weavings. Visitors to the site can tour the Hubbell home and grounds. Preserved as it was during the family's residence, the home displays paintings and drawings by non-Native artists, period furniture, and a Native American basketry collection. It also includes a number of unique weavings that take their place as part of the furnishings.

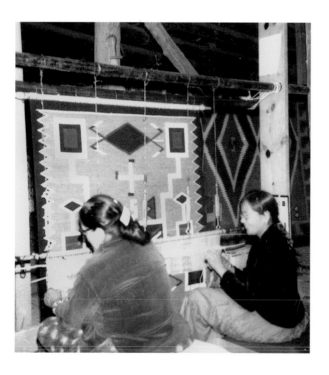

FIGURE 2.2. Grace Henderson Nez (left) and Mary Henderson Begay (right) at the Hubbell Trading Post, c. 1973. Hubbell Trading Post National Historic Site Administrative Record. Photograph by David Brugge, 1970.

While the weavings displayed at the Hubbell home appear to have been produced at the height of the trading post period, they were not, in fact, created at that time. Rather, they were made in the late twentieth century by a group of 13 Navajo weavers paid to replicate, down to the most minute detail, the rugs originally decorating the residence.[11] Weavers who participated in the project were Helen Kirk, Helen's mother Helen Davis (also known as Ylildesbah Davis) and mother-in-law Elizabeth Kirk, Evelyn Curley, Faye Yazzie, Shirley Yazzie, Betty Shirley, Sadie Begay, Louise Begay, Mae Jim (formerly Mae Curtis), Sadie Curtis, and Mary Henderson Begay (formerly Mary Lee Begay).[12] Over the course of 20 years, this group of women, all from the Ganado area, rewove 15 rugs while visitors to the trading post watched (figures 2.2 and 2.3).[13] The majority of the weavings were completed in a five-year period from 1971 to 1975 in the post's wareroom. In the 1980s, the weavers were moved to the park's visitor's center, where several more pieces were completed in 1984, 1985, and 1990, and where the women continue their demonstrations today. Currently, two women, Mary Henderson Begay and Helen Kirk, weave regularly at the post. The organization now known as the Western National Parks Association (formerly the Southwest Parks and Monuments Association), which also sells merchandise in the visitor's center and in the adjacent trading post, has paid the weavers' salaries from the project's start until today.

During the course of the Hubbell reweaving project, the weavers dyed the wools used so as to duplicate the originals, and included the original weavers' "mistakes" in pattern and dyes. As Mary Henderson Begay explains,

> We copied mistakes such as the discolorations in the reds and browns and any other flaws in the weave. We dyed yarn with red dyes and dyed many batches of yarn in different shades of red to match the colors in the old rugs on the floor. We obtained different shades of browns to match the old rugs. We made the rugs to look exactly like the old ones in Hubbell's house.[14]

The original weavings were then removed from the home for storage onsite, and the rewoven copies took their place (figures 2.4 and 2.5).

Replication of past designs is not a new practice for Ganado weavers. Hoping to generate an increased market for Navajo textiles, Hubbell encouraged weavers to return to the simple stepped patterns and stripes of early Navajo weaving.[15] Feeling that Navajo weaving designs had become degraded through excessive use of serrate patterns and the bright aniline-based colors that had become commercially available, he encouraged weavers to simplify and promoted designs composed of simple stripes and terraced elements and a color palette consisting of natural grays, blacks,

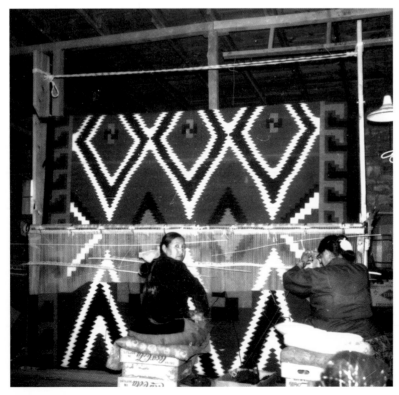

FIGURE 2.3. Helen Kirk and her mother-in-law Elizabeth Kirk working in the Hubbell wareroom, c. 1973. The rug they are working on now occupies the dining room of the Hubbell home. Hubbell Trading Post National Historic Site Administrative Record. Photograph by David Brugge, 1970.

and white, combined with aniline-based red. Hubbell employed several Euro-American artists, including Eldridge Ayer Burbank to record old Navajo weaving designs in oils and displayed the resulting paintings at his trading post, showing them to weavers and encouraging them to use the designs as guides. Weavers complied with his request. The resulting "Ganado Style" weavings proved highly marketable and continue to be identified with the region today.

Hubbell encouraged Navajo weavers to use simple banded and terraced designs and a limited color range primarily for commercial reasons. The cultural significance of the designs he promoted was secondary to their market appeal. But these designs carry important historical and cultural associations for Navajo weavers. Both Mary Henderson Begay and her mother Grace Henderson Nez have woven in the Ganado Style for many years (Plates 1 and 2). Closely identified with Hubbell Trading Post, Henderson Begay and Henderson Nez weave in other styles as well, but they express a preference for the "old style"

FIGURE 2.4. Original rug from Hubbell home dining room. Hubbell Trading Post National Historic Site, HUTR 3237. Photograph by Charles Voll, 1970.

that Ganado Style weavings perpetuate. Henderson Begay especially enjoys weaving Chief Blankets because of their historical significance to the Navajo (Plate 3). She explains:

> These were the leaders' blankets. They're known as the Chief Blanket. A lot of the older weavings were very simple, just bands, maybe a little bit of color in-between your bands. It is believed that these were blankets a long time ago, and the women used to weave like that, and as time went on designs evolved. But designs weren't very intricate or complicated, and I often think of those designs or those patterns and I like them. I love them. When I think of the Chief Blankets, it makes me sad. I often feel sad for them. I feel sad for the blankets because of the significance of the Chief Blanket—because a long time ago our people made the Long Walk. That's why I like them, because of how they were used and when they were used in times of hunger, in times of imprisonment. I always refer to them as "blankets of our ancestors," our great-great-grandparents.

Grace Henderson Nez's preference for stepped designs stems in part from her experience as a basket weaver. Learning to weave baskets from her Hopi sister-in-law, Henderson Nez is one of a small number of Navajo women who have continued to produce ceremonial baskets. The importance of basketry-derived stepped designs to Henderson Nez can be seen in a recent "sampler" weaving that replicates the patterns of the ceremonial manta and the ceremonial basket (2004,

FIGURE 2.5. Replica rug woven by Helen Kirk and Elizabeth Kirk as it appears in the Hubbell home dining room today. Hubbell Trading Post National Historic Site, HUTR 4207. Photograph by Ed Chamberlin, 2006.

figure 2.6). The design she used in this weaving is also one of the old style designs recorded by Burbank that still hangs on the wall of the Hubbell Trading Post today (figure 2.7).

Terraced designs, which find their basis in early Navajo basketry, carry significant cultural associations. In the basketry design tradition that serves as their source, the terraced figures represent mountains and clouds and signify protection and nurture, and serve to identify the wearer's physical being with the natural environment (figure 2.9).[16] The *biil* or "rug dress" is a two-piece woven dress worn by Navajo women on special occasions (figure 2.8). It carries particular significance when worn during the puberty ceremony (*Kinaalda'*), serving as a signifier of the young woman's new capacity to bear children and her identification with Changing Woman, who is herself closely identified with the cyclical, seasonal character of the natural environment. Maureen Trudelle Schwarz asserts that two-piece dresses and baskets are homologues, and this association "links dresses directly to Navajo cosmology." "Just as the basket serves as a visual record of Navajo history," Schwarz explains, "the dress serves as a visual representation of the Navajo way of life and simultaneously as a means of identification between the wearer and her world."[17]

FIGURE 2.6. Grace Henderson Nez, *Ganado Wall Hanging*, 2004. Aniline-dyed commercial wool. 24.5 x 24.5 in. Edwin L. and Ruth E. Kennedy Southwest Native American Collection, Kennedy Museum of Art, Ohio University, KMA 2004.11.01.

FIGURE 2.7. Eldridge Ayer Burbank, *Woman's Wearing Shoulder Blanket* (Hubbell Trading Post Rug Study). Oil on canvas. Hubbell Trading Post National Historic Site, HUTR 2788. Photograph by Ed Chamberlin, 2006.

For many years, Henderson Begay and Henderson Nez served as demonstrators at Hubbell Trading Post. Grace no longer weaves at the post, but Mary currently maintains a full-time position there and earns a regular hourly wage. Tourists may watch Mary and Helen Kirk execute weavings from start to finish, and then the visitor can purchase them at the Hubbell Trading Post gift shop. The weavers' performance contributes to the tourist appeal of the post as an historic site. Exemplifying what cultural theorist Dean MacCannell calls the "pre-modern work display," it plays an important role in the production of self-identity for both visitor and weaver.[18] For the visitor, it provides the basis for construction of self as a modern, autonomous subject. For the weaver, it provides the opportunity for a form of autoethnographic expression that functions to preserve and propagate important traditional cultural values.[19]

In his best-known scholarly study, *The Tourist: A New Theory of the Leisure Class*, MacCannell explains how the "work display," or "the museumization of work and work relations" functions to produce identity.[20] MacCannell asserts that, for the modern Euro-American, tourism functions as a mechanism of self-discovery.[21] Sightseeing is a means by which the tourist attempts to overcome the discontinuities of modern life, "incorporating its fragments into unified experience."[22] In the past, MacCannell asserts, work functioned as an organizing principle of social relations. Today, work has been displaced by leisure as a socially defining activity. One's leisure pursuits have come to define one's position in society, and tourism is one of the leisure pursuits that most effectively works to define this position. Today, MacCannell points out, the "work display" itself has become a tourist attraction.[23]

Navajo weavers at Hubbell Trading Post provide especially vivid examples of MacCannell's work display. Thousands of tourists yearly observe them at work. In this performance, the weaver assumes the role of pre-industrial craft worker. Bound to tradition, constrained to production of culturally proscribed forms by ancient means, she serves by contrast to construct the tourist as a free and autonomous modern individual. The tourist, stepping back in time, is—he or she believes—offered a privileged "behind-the-scenes" position. The tourist is offered that which he or she most desires, a glimpse of what MacCannell labels the "back regions," the area that is believed to reveal truth devoid of artifice, devoid of staging.[24]

For the weavers, employment as demonstrators at Hubbell Trading Post allows them the opportunity to display particular cultural competencies. They are able to show a depth of traditional cultural knowledge and practice while, at the same time, through their employment and the sale of the weavings it engenders, they are provided with the means to successfully negotiate the world of the tourist. They are offered a privileged

position whereby they are able to participate in the process that art historian Ruth Phillips asserts produces tourist art: "a careful, anthropological study of the material culture and aesthetics of the Western other by Native artists and craftspeople."[25] At the Hubbell Post, the observer becomes the observed.

Weavers at Hubbell are also enabled to practice, on a daily basis and with a stable income, a traditional form of expression that not only provides for their material sustenance but also enables them to play vital roles in the perpetuation of traditional culture. Mary's performance at Hubbell allows her to maintain a lifestyle that is of value to her. Interested in retaining old designs as a way of keeping cultural historical memory alive, Mary has been able to participate in the preservation of important cultural artifacts that bear evidence of their transcultural context of production and reception. Chief Blankets have a particular emotional appeal to Mary because of Navajo history. She wants to keep the memory of this history alive and sees her weaving as a means to do so. Henderson Begay's performance at the visitor's center has allowed her agency in her personal life through providing a steady income, and it has allowed her to provide for her family. While in MacCannell's terms her performance may constitute a museumization of work, for her it serves as a source of independence and autonomy and provides the opportunity for perpetuating important cultural practices and values. Mary feels

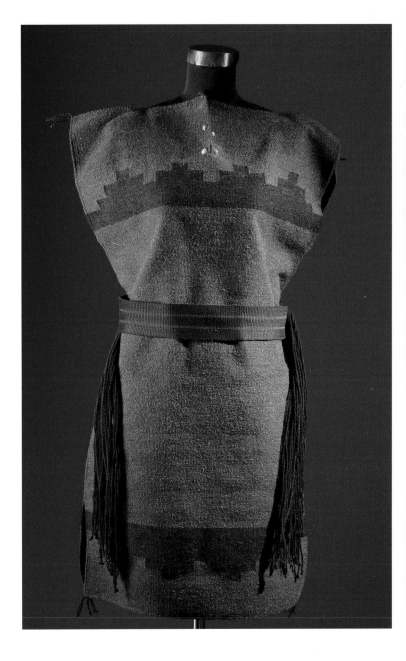

FIGURE 2.8. D. Y. Begay, *Biil dóó Beeldléí: The Dress*, 2005. Natural (undyed) and vegetal-dyed wool. 37 x 23 in. Collection of D. Y. Begay. Begay's color choice deviates from the norm. *Biils* are more typically woven in red and black.

19

a great responsibility to ensure that her children will carry on the weaving tradition that has meant so much to her family. She often tells her children that they should carry on the weaving tradition, and they

should teach their children. They should teach my grandchildren about weaving, too. I do tell my daughters that. I think that, if they take on the weaving tradition, move on with my weaving tradition—and I know I can pass down the knowledge—if they continue to carry on, then they will also think the same way as I did, caring for the weaving.

For Henderson Begay, weaving provides the opportunity for performance that demonstrates particular cultural competence. The knowledge and skill that have been passed down to her from previous generations carry significant responsibility. Having achieved a high level of mastery of her art, she must now convey her knowledge to her daughters and granddaughters. Her daughter, Gloria Jean Begay, feels the weight of this responsibility as a fledgling weaver. Gloria expresses her trepidation, saying she wishes to carry on the family tradition, but is not sure if she's ready to take it on: "You have weaving songs. There are certain things you have to do before you start. There are certain things you do traditionally after you get done... and it's not just fun. It's work! It's *hard* work!" Despite her reservations, Gloria has recently turned to full-time weaving as a primary vocation (Plate 4).

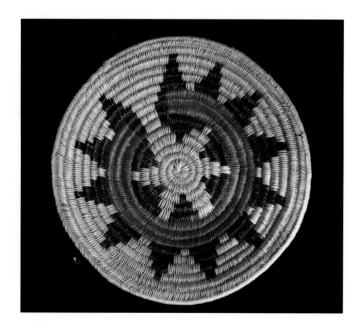

FIGURE 2.9. Unknown Artist, *Navajo Ceremonial Basket*. Late twentieth century. Sumac, aniline dye. 15.5 in. diameter. KMA EDU200.003.4.

Navajo Weaving and the Performance of Traditional Gender Roles

While Gloria Begay often finds the weight of tradition onerous, other weavers of her generation enthusiastically embrace this responsibility. Lillie Thomas Taylor and her daughters Rosie Taylor and Diane Taylor Beall are not daunted by the weight of tradition. Rather, they find it to be a source of sustenance and a means by which their roles as family and community members are secured. Rosie and Diane see their practice as an homage to both their female and male ancestors. While their mother, Lillie Thomas Taylor, and their grandmother, Lillian Taylor, taught them to weave, their father, Carl Taylor, conveyed valued traditional knowledge that informs their work in significant ways. A respected elder and traditional ceremonial practitioner, Carl Taylor was well known in their Indian Wells community as a healer who possessed a vast knowledge of herbal medicines and centuries-old healing practices.

Taylor family members use natural dyes from local sources in their weavings, producing a wide array of colors. Their works are executed in a range of styles, but the daughters show a preference for simple banded designs with stepped and pictorial elements often integrated into the bands. Diane Beall's *In Honor of a Medicine Man (Two Point Canyon Rug)* (2004, Plate 13), was woven in natural (undyed) and aniline-dyed wools, combined with wool dyed with vegetal sources gathered from Two Point Canyon, which is located near the family home and served as one of Carl Taylor's favorite sources for medicinal herbs. Diane explains the significance of the natural dyes she used in this piece:

> This weaving is a tribute to my late father, Carl Taylor, who was a medicine man for many years. . . . He studied various plants in different regions across the Navajo Nation to help find a cure for his patients. . . . On many occasions I had the opportunity to observe his finding of herbs, where he explained how each is used and for what purposes.

Rosie Taylor's weaving *Family Teaching* (2004, Plate 14) executed in natural, aniline-, and vegetal-dyed handspun wool (from sources including walnuts, rabbit brush, sumac, and juniper), is similarly motivated. Rosie explains that her weaving primarily concerns "the traditional way of life and how herbal medicine was used among my family."

Examination of the imagery in Lillie Taylor's weavings reveals that her work is similarly autoethnographic. A number of Taylor's children have been recognized as superior jewelers. Rosie and her husband Leonard Gene collaborate on jewelry, and several of Rosie's siblings are accomplished jewelers. Lillie recognizes this family achievement through the inclusion of jewelry designs in her weavings. *In the*

Path of the Four Seasons (2004, Plate 12) bears a crescent form that references the *naja*, the distinctively shaped pendant found on squash blossom necklaces. In an untitled weaving from 1989, Lillie incorporates a representation of an entire squash blossom necklace (figure 2.10). Lillie also recognizes her husband's role as traditional healer in her work. A reference to Carl Taylor's ceremonial practice is found in the horned toad design that fills the border of *In The Path of the Four Seasons*. Lillie has woven sandpainting textiles and *ye'ii* rugs in the past; and, as the widow of a traditional ceremonial practitioner, she is intimately familiar with the imagery commonly found in ceremonial practice. The horned toad, which plays an especially prominent role in the Red Antway Ceremony, is one such image (figure 2.11).

The Taylors employ a rich and complex imagery reflective of personal experience, cultural history and familial values. While their finished weavings serve as means to convey such values, the practice of weaving itself, the preparatory activities of gathering dye plants, and cleaning, carding, and spinning of the wool, serve equally important roles. As Diane explains

> My sisters and my aunt and my grandmother also weave, and I believe that that's what was given to us, as Navajo, for the women. It was given to us because it's our job to carry on, to provide for ourselves. If you're a woman, it is your job to know how to weave, to know the process of weaving.

Equally committed to the belief that knowledge of the process and practice of weaving is necessary to proper Navajo womanhood, Rosie Taylor is teaching her two young daughters, Amber and Twyla Gene, to weave (Plate 15). Rosie believes that one of the most important things weaving teaches young women is the necessity of patience:

> You have to have a lot of patience. It's a lot of patience that teaches weaving, that is behind all that weaving. . . . I think it's a way to bring them back to having their patience. . . . I think teaching them is the most important thing. Having the patience. That is how I have been teaching my girls, teaching them to be patient at all times. No matter how hard the weaving is, they have to be patient. With the rug and also with themselves.

Women in the Irene Clark family are equally committed to passing their knowledge of Navajo weaving on to succeeding generations. This heritage includes a distinctive design element that bears special significance for the Clarks because of its family history. The hair bun (or *tsiiyéél*), a design that was originated as a weaving motif by Irene Clark's mother, Glenabah Hardy (Plates 5 and 6; figures 2.12 and 2.13), is widely recognized in Navajo culture because of its association with important cultural practices and traditional feminine

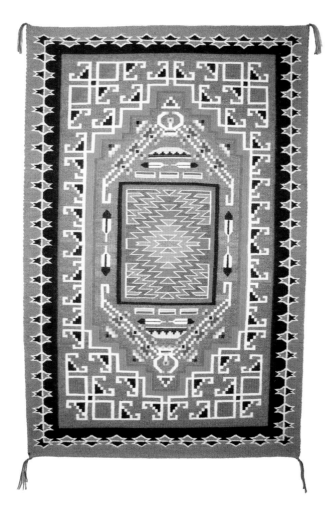

FIGURE 2.10. Lillie Taylor, Untitled, 1989. Natural (undyed), vegetal-dyed, and aniline-dyed handspun wool. 32 x 48 in. Private collection. Photograph by Bill Faust.

Crystal wavy-line pattern that is achieved by alternating pairs of wefts of contrasting colors. But they deviate from other Crystal weavers in their use of the hair bun design.

While the hourglass-shaped hair bun design may seem simply a visually pleasing design innovation, its use, in fact, constitutes a tribute to the disciplined thought, the patience and tenacity that weavers repeatedly say is necessary to their practice. Anthropologist Maureen Trudelle Schwarz reports that, when she queried traditional Navajo women about the significance of this hairstyle, they stressed its associations with disciplined thought. Schwarz's informants explained to her that, when a Navajo woman wears her hair in the traditional bun, she demonstrates that she is "thinking in the proper way,"[26] that she is strong and her "mind is good,"[27] that her "mind is all set,"[28] and her "thinking is controlled."[29] Schwarz reports: "When I asked women what the relationship was between thinking and the hair bun, they told me the bun helped contain and control one's accumulated knowledge so that one could think effectively and not have one's thoughts 'scattered'."[30]

When Navajo women wear the traditional hair bun, they demonstrate conformity with their culture's conception of proper womanhood. They participate not only in performance of femininity but performance of ethnicity. As Schwarz explains, the traditional hair bun is recognized today "as a strong symbol of ethnic identity among contemporary Navajo."[31]

attire. Clark family members use vegetal dyes and adhere to an overall design configuration that is typical of weavers of their region, the Crystal area (Plates 7, 8 and 9). Their weavings are banded and unbordered and show the distinctive

Multiple generations of the Clark family have retained the hair bun design. They have also retained a particular color palette derived from the plants surrounding their home in the Crystal region of the Navajo Reservation. While encouraged to deviate from the palette that has become their family's trademark color scheme, Irene, Glenabah and Irene's daughter Teresa have resisted. Irene expresses her desire to remain autonomous in her choice of color scheme:

A lot of people use commercial colors—all these oranges and pinks. I was making a rug and the trader said "This is out of style. Don't make them like that. Use these commercial colors." And I said "Are you going to tell me what to make and how to do it? These are my favorite colors. This is the real natural colors I make with these plants, and these other colors are colors that I don't know."

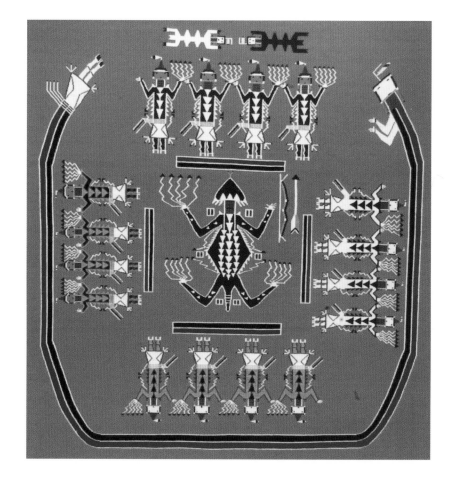

FIGURE 2.11. Alberta Thomas. *Black Horned Toad and Horned Toad People, from the Red Ant Way Ceremony*, c. 1968. Commercial wool. 53.5 x 57.5 in. Edwin L. and Ruth E. Kennedy Southwest Native American Collection, Kennedy Museum of Art, Ohio University, KMA 91.023.33.

Consenting to give the new colors a try, Irene produced a prize-winning piece. However, the experience only strengthened her resolve to maintain the family's signature palette:

> So I make a rug, but I am not real proud of it. It's a little bit of this and that color. . . . I made it about four feet by six feet—a big rug. So I sold it to a museum in Flagstaff, and it won the Best of Show. But that was the last time of it. I said "I'd rather stay with my own colors."

Clark family members have resisted pressure to produce works that are in consonance with particular Euro-American design trends and have persisted in creating weavings that conform to their own tastes and values. The Clarks' preference for locally derived plant dyes evidences a particular cultural and personal ethic regarding proper stewardship and knowledge of one's environment. Irene explains:

> It's a blessing that we have these plants. . . . Some of these are medicines and herbs that some of us don't know. Some can be healing and helps here and there. So I always say "Thank you, Mother Earth, that you have all this for us and we use it."

FIGURE 2.12. Gerald Nailor (Navajo), *Navajo Weavers*, 1943, detail. *Fresco secco* mural, fifth-floor penthouse employees lounge, Department of the Interior Building, Washington, D. C. National Archives photograph 121-PS-4845.

FIGURE 2.13. Clark family hair bun design. The repeated design motif found in Clark family weavings differs from one piece to the next, but it always retains a basic geometric configuration that allows the viewer to recognize it as a representation of the traditional Navajo hair bun.

25

As Irene explains, the plants that she uses as dye sources and medicinal cures serve as opportunities for learning and exploration and as means to experience the symbiotic relationship of humans and the natural environment. Such knowledge constitutes part of the cultural legacy that is uniquely conveyed through weaving practice, knowledge that Clark family members are firmly committed to passing along to future generations.

Contemporary Navajo Weaving as Autoethnographic Expression: D. Y. Begay

The work of D. Y. Begay, perhaps more than that of any weaver discussed here, demonstrates how Navajo weaving can function as an important form of autoethnographic expression that serves to perpetuate traditional values and lifeways.[32] Begay interrogates the cultural practice of weaving, systematically studying all of its elements, exploring how the designs and the very materials themselves function as signifiers. Through the practice of weaving and through dialogue with other weavers, Begay has committed herself to the task of more fully understanding how her art form functions to convey and produce meaning. Begay explores the language of Navajo weaving, its rich fund of historical designs, family designs, weave patterns, and vegetal dye sources, recording her findings for use in her own weaving practice and for further use by other weavers.

Like Navajo weavers of the past, D. Y. learned the art of weaving from her mother and grandmothers. But she has tapped into a wealth of additional sources to further her artistic development. Since completing an art education degree from Arizona State University, Begay has traveled worldwide to meet with both native and non-Native weavers, exchanging information on natural dye sources, weaving techniques and patterns. She has also extensively studied museum collections, examining textiles from widely diverse areas and time periods. And, experimenting with a wide range of materials and techniques, she has converted to action the knowledge thus gained.

Begay serves on numerous advisory boards and provides curatorial assistance to museums with major Navajo weaving collections, including the Wheelwright Museum in Santa Fe and the Kennedy Museum of Art in Athens,

FIGURE 2.14. D. Y. Begay, *Wedding II*, 1998. Natural (undyed) and aniline-dyed wool. 37 x 60 in. Private collection.

Ohio. She is Vice-President of the Board of Directors of The Taos Center of Southwest Wool Traditions, a non-profit educational organization devoted to the promotion of local sustainable agriculture, the production and dissemination of organic wool and natural dyes, and the maintenance of the cultural traditions of the southwest.

But the rich variety of Begay's own weaving provides perhaps the best evidence of the benefits of her wide-ranging exploration. Space does not permit a complete presentation of the development of her weaving, but a brief overview provides a glimpse of its scope. Most apparent in Begay's work is a concern with examining how surface designs encode meaning. She has explored the design traditions of Navajo weaving and what they signify, from the simple stripe patterns of the earliest examples of the form to the highly complex designs of varied regional styles.

Begay does not simply replicate traditional patterns. She introduces subtle variations that reference the transcultural context of Navajo weaving's genesis and development. For example, in *Wedding II* (1998, figure 2.14) she replaces the highly limited color palette of traditional Chief Blankets with a range of rusts and golds derived from natural dye sources commonly found in contemporary weaving. In Begay's work, even forms such as Chief Blankets, which seem inviolable because of their now-iconic status as signifiers of Navajo culture, are subject to alteration and innovation.

Begay has also explored the surface designs that have played significant roles in the signifying economies of other Native American cultures. *Dakota Style* (2002, figure 2.15) and *Cheyenne Style* (2002, Plate 16) replicate the surface designs of painted rawhide pouches used by Plains tribes to hold and preserve a wide variety of items. Much like the Chief Blanket, the *parfleche* is characterized by dynamic surface design that assumes different visual form with use, completing a geometric pattern not otherwise apparent. When in use, the rawhide pouch folds over, forming a new surface design as it envelops and protects its contents.

Begay has explored other traditional forms that perform a similar function, enveloping and marking that which they contain. Among these are *biils* and mantas, which bear traditional stepped motifs derived from ceremonial basketry such as *Child's Manta* (2004, Plate 17) and *Biildóó Beeldléí: The Dress* (2005, figure 2.8), both

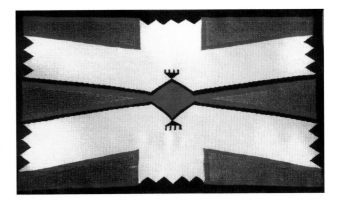

FIGURE 2.15. D. Y. Begay, *Dakota Style*, 2002. Natural (undyed), vegetal- and aniline-dyed wool. 22 x 39 in. Collection of Scotty and Peter Gillette.

woven in indigo-dyed and natural undyed wools. Begay draws on the same basketry-derived iconography as Grace Henderson Nez. The landscape reference of these designs becomes especially apparent when one views these traditional garments in conjunction with Begay's recent landscape weavings.

In this most recent series, Begay explores correspondences of the "step" and "terrace" patterns of traditional Navajo design patterns to the literal steps (steppes) and terraces of the Navajo Reservation and the surrounding area. Begay explains that these weavings incorporate the colors and other landscape features she observes:

> While driving around through different locations on the Navajo Reservation, places like Chinle, Nazlini, Dilkon, Leupp, or Sanders, Arizona, I mentally capture images and colors to potentially incorporate into my weavings. Many of the images that resemble the landscapes of the southwest area have transpired into my rugs: the colors in a sunset, the outline of a mesa on the horizon, or a hogan sitting by itself on a flat plain.[33]

When viewed in sequence, Begay's landscape series constitutes an extended meditation on the correspondences between the geometric designs of traditional Navajo weaving and the natural environment (figures 2.16, 2.17 and 2.18).[34] The landscape of the Navajo homeland, Begay demonstrates, serves as both literal and figurative source of Navajo weaving.

FIGURE 2.16. D. Y. Begay, *Dilkon*, 1998. Natural (undyed) and vegetal-dyed handspun wool. 33 x 27 in. Collection of Richard and Jacquelyn Daniels.

FIGURE 2.17. D. Y. Begay, *Lori's Landscape*, 2002. Natural (undyed) and aniline-dyed handspun wool. 35 x 60 in. Collection of Lori L. Golberg.

While Begay constantly innovates, she is careful to emphasize that she never deviates too far from tradition:

> The Navajo weaving technique that I use has been passed down from my grandmother to my mother and now to me. However, the designs and the colors that I use are very different from those used by the older weavers in my family.[35]

While D. Y. learned much from her own family members, she also learned from other Navajo women:

> I especially have learned a lot of things from the grandmothers just by the presentations of their stories, what they believe and how important it is to them, how important weaving is with their families, passing on the knowledge, and there is a great lesson to be learned about that, just listening to each one of the weavers talking about how important it is to know how to weave, to think about the process and to think about where the weavings will go, who's going to carry on the tradition of weaving.

FIGURE 2.18. D. Y. Begay, *Alabama*, 2005. Natural (undyed), vegetal- and aniline-dyed handspun wool. 37 x 55 in. Collection of Susan and Robert Rich.

And then some of the other things that I've learned are that it is very important for each weaver, for each person in the family, to really hold onto those traditions and I've heard this over and over by the grandmothers I have worked with. The 90-year-old grandmothers that I have worked with have reestablished that information for me, and I think that's very, very important.[36]

Begay feels a responsibility to record this information for younger weavers and is assembling an archive for this purpose. She also carefully documents her own experiments with vegetal dyes:

I enjoy searching for and investigating plants that grow on our family land. Many of the plants are used in ceremonies for healing. And some of these plants are also suitable for producing

naturally handsome earth tone colors for my weavings. It is very important to me to document these uses of our native plants. I hope this documentation will be useful to the young Navajo weavers and researchers.[37]

For Begay, experimentation with natural dyes facilitates her exploration of the natural environment and deepens her understanding of the ways in which traditional cultural beliefs and practices are intertwined with culturally specific understandings of the natural world.

As the Henderson Begays, Taylors and Clarks attest, the understandings that D. Y. Begay describes are uniquely achieved through the process of traditional Navajo weaving. For Begay, as for other Navajo women, weaving and its attendant processes and practices function as forms of creative thinking and means to a deepened understanding of one's culture, one's environment, and one's place in the world. As bearers of the knowledge necessary to achieve such insights, Navajo weavers feel a great responsibility to pass this unique cultural legacy along to future generations. Irene Clark expresses their common desire: "We want our kids to go on with it. We want them to learn what it really means."

Acknowledgments

I would like to thank the weavers who participated in this project. They welcomed us into their homes, graciously sharing their stories and insights, and then traveled from Arizona and New Mexico to Southeastern Ohio to make a personal connection with our viewers. Their generosity and enthusiasm have been invaluable.

I would especially like to thank *Weaving is Life* co-curator D. Y. Begay. D. Y. facilitated visits with weavers, conducting interviews in Navajo and then translating them into English. She participated in all aspects of planning and execution of the exhibition, offering valuable insight and incomparable expertise. This exhibition and catalogue would not have been possible without her involvement.

Kennedy Museum of Art staff, students, and community members also played vital roles in completion of *Weaving is Life*. Sally Delgado, Jeff Carr, Paul Legris, Deanna Cook, Tom Patin, Bruce Westfall, Dave Urano, Betty Reese, Rick Fatica, Susan Greene, Mariel Betancourt and Mike Rodriguez are Kennedy Museum and Ohio University staff who were central to its success. Student assistants included Whitney Fromholtz, Larry Shields, Nick Polizzi, Mark Watson, Cara Romano, Janeece Henes, Katrina Brickner, Josh McConaughey, Cara Williams, Julie Rosengarten, Rachel Byers, Brigette Skope, James Stennies, George Amagnoh, Eric Bockmuller, and Dave Royer.

I would also like to thank Navajo weaver and scholar Wesley Thomas for his assistance and Janet Berlo for the enthusiastic support she has provided and the wonderful essay she contributed to this catalogue.

Notes

[1] Walter Rendell Storey, *New York Times Magazine*, November 6, 1932, SM12.

[2] See Helen M. Bannan, *"True Womanhood" on the Reservation: Field Matrons in the U.S. Indian Service*, Southwest Institute for Research on Women, working paper no. 18. Women's Studies, University of Arizona, Tucson, Arizona, 1984; Margaret D. Jacobs, *Engendered Encounters: Feminism and Pueblo Cultures*, 1879-1934 (Lincoln: University of Nebraska Press, 1999); and Valerie Shere Mathes, "Nineteenth-Century Women and Reform: The Women's National Indian Association," *American Indian Quarterly* 14 (1990): 1-18. There is a growing literature on the ways in which non-Native women have used Native American women's arts and crafts to inculcate gender norms. See, for example: Jacobs, *Engendered Encounters* and Molly H. Mullin, *Culture in the Marketplace: Gender, Art, and Value in the American Southwest* (Durham: Duke University Press, 2001).

[3] See Marian Rodee, *Southwestern Weaving* (Albuquerque: University of New Mexico Press, 1977) and *Weaving of the Southwest* (West Chesster, Penn.: Schiffer Publishing Co., 1987); Kathleen Whittaker, *Southwest Textiles: Weavings of the Navajo and Pueblo* (Los Angeles: Southwest Museum and Seattle: University of Washington Press, 2002); and Joe Ben Wheat, *Blanket Weaving in the Southwest*, ed. Ann Lane Hedlund (Tucson: University of Arizona Press, 2003).

[4] Ann Lane Hedlund's "Give-and-Take: Navajo Grandmothers and the Role of Craftsmanship," in *American Indian Grandmothers: Traditions and Transitions*, ed. Marjorie M. Schweitzer (Albuquerque: University of New Mexico Press, 1999), 53-78 provides an excellent analysis of the values that inform Navajo weaving.

[5] Irene Clark, personal communication, 2004. Unless otherwise noted, all quotes from members of the Clark, Henderson Begay and Taylor families are from interviews conducted by Jennifer McLerran and D. Y. Begay in the weavers' homes in March of 2004.

[6] This is D. Y. Begay's translation (personal communication with author, 2006).

[7] Julia Jumbo, personal communication with author, 2004.

[8] Ruth B. Phillips, *Trading Identities: The Souvenir in Native North American Art from the Northeast, 1700-1900* (Seattle: University of Washington Press, 1998), 19-20.

[9] D. Y. Begay, "Shi'Sha'Hane (My Story)," in *Woven by the Grandmothers: Nineteenth-Century Navajo Textiles from the National Museum of the American Indian*, ed. Eulalie H. Bonar (Washington, D.C.: Smithsonian Institution Press in association with the National Museum of the American Indian, Smithsonian Institution, 1996), 17.

[10] Begay, "Shi'Sha'Hane (My Story)," 27.

[11] Ed Chamberlin, personal communication with author, 2006; and Don Dedera, *Navajo Rugs: How to Find, Evaluate, Buy, and Care for Them* (Flagstaff: Northland Press, 1975).

[12] Ed Chamberlin, Curator, Hubbell Trading Post National Historic Site, lists Mary Henderson Begay's mother Grace Henderson Nez as one of the participants in the reweaving project. However, Mary Begay explains that, while her mother may have participated in various demonstrations at the Hubbell Trading Post at the time, she never directly participated in the reweaving endeavor (Mary Henderson Begay, personal communication with author, 2005).

[13] Chamberlin notes: "Fifteen rugs were copied during this project and are now used in the Hubbell family home. One of the copies was woven with colors that did not match the original and it was sold to a visitor" (Ed Chamberlain, personal communication with author, January 2006).

[14] Mary Henderson Begay, personal communication with author, 2005.

[15] Rodee, *Southwestern Weaving*, 43-44, and *Weaving of the Southwest*, 89-98.

[16] Maureen Trudelle Schwarz, "The *Biil*: Traditional Navajo Female Attire as Metaphor of Navajo Aesthetic Organization," *Dress* 20 (1994): 75-81; and *Molded in the Image of Changing Woman: Navajo Views on the Human Body and Personhood* (Tucson: University of Arizona Press, 1997).

[17] Schwarz, *Molded in the Image of Changing Woman*, 186.

[18] Dean MacCannell, *The Tourist: A New Theory of the Leisure Class* (New York: Schocken Books, 1976), 34-37, 58-59.

[19] James Buzard has defined autoethnography as "the study, representation, or knowledge of a culture by one or more of its members." Autoethnoegraphic practice constitutes "the social realization of selfhood." See James Buzard, "On Auto-Ethnographic Authority," *Yale Journal of Criticism* 16 (2003): 61-91. Mary Louise Pratt introduced the terms "autoethnography" and "autoethnographic expression" to recent postcolonial discourse. See Mary Louise Pratt, *Imperial Eyes: Travel Writing and Transculturation* (London and New York: Routledge, 1992).

[20] MacCannell, *The Tourist*, 36.

[21] Ibid, 5.

[22] Ibid, 13.

[23] MacCannell regards the work display as a form of cultural production that marks "the death of industrial society and the beginning of modernity: a museumization of work and work relations, a cultural production I call a *work display*" (36).

[24] Ibid, 91-107.

[25] Phillips, *Trading Identities*, 116.

[26] Dooley, 8/19/92, in Schwarz, *Molded in the Image of Changing Woman*, 92.

[27] Jones, 7/25/91, in Schwarz, *Molded in the Image of Changing Woman*, 92.

[28] H. Ashley, 7/23/91, in Schwarz, *Molded in the Image of Changing Woman*, 92.

[29] Bekis, 7/28/93, in Schwarz, *Molded in the Image of Changing Woman*, 92.

[30] Schwarz, *Molded in the Image of Changing Woman*, 90.

[31] Ibid, 92.

[32] D. Y. Begay, "A Weaver's Point of View," in *All Roads are Good: Native Voices on Life and Culture*, ed. by W. Richard West (Washington, D.C.: Smithsonian Institution Press in association with the National Museum of the American Indian, Smithsonian Institution, 1994), 80-89; "*Shi'Sha'Hane* (My Story)," 13-27; and personal communications with author, 2003-2006.

[33] D. Y. Begay, personal communication, 2003.

[34] These correspondences were particularly well-demonstrated in the 2003 exhibition of Begay's weavings at the Wheelwright Museum of the American Indian, *Another Phase: Weaving by D. Y. Begay*. For full-color reproductions of the weavings shown and an accompanying statement by the artist, see: D. Y. Begay, *Another Phase: Weaving by D. Y. Begay* (Santa Fe, N.M.: Wheelwright Museum of the American Indian, 2003).

[35] D. Y. Begay, personal communication with author, 2003.

[36] D. Y. Begay, personal communication with author, 2004.

[37] D. Y. Begay, personal communication with author, 2003.

"It's up to you—": Individuality, Community and Cosmopolitanism in Navajo Weaving

Janet Catherine Berlo, Ph.D.

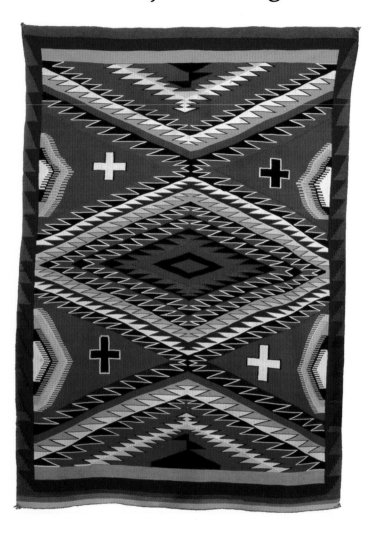

FIGURE 3.1. Unknown Navajo Artist, *Germantown Eye Dazzler Rug*, c. 1890. Aniline-dyed wool. 73 x 98.5 in. Edwin L. and Ruth E. Kennedy Southwest Native American Collection, Kennedy Museum of Art, Ohio University, KMA 91.023.189.

Although this catalogue focuses on twentieth-century works, numerous threads of continuity link contemporary and historic Navajo textiles. Among these are an interest in materials and markets that range from the local to the distant, a constant interplay between abstraction and representation, and a dynamic relationship between deeply held community values and individual creativity. A common Navajo phrase in regard to many activities is *aashi bi'bohlii*—"it's up to you," signifying that one is accountable for one's own behavior, and in the realm of the arts, one's own creativity. In this essay, I shall briefly examine some aspects of these interrelated issues of materials, markets, aesthetics, individuality, and community as they existed in historic times as well as the present.

Materials and Markets: From the Local to the Global

As curator Jennifer McLerran points out in her essay in this volume, Navajo weaving is a transcultural process; meaning is produced on both sides of the loom. Sometimes, those who admire Navajo textiles make the mistake of thinking that items made with only local, or "natural" materials are

more "authentic" than those made with imported ones. Yet Native cultures and their objects of manufacture have been in conversation with a global economy for more than 500 years. The Navajo, living relatively near a crossroads of cultures (Native, Hispanic, Anglo) for several hundred years, have profited from the diverse materials that have come west down the Santa Fe Trail from the eastern U.S. and Europe, or north on the Camino Real, from Mexico City, the capital of New Spain; today, of course, a plethora of international materials are available at the local trading post, at Wal-Mart, or can be ordered on the Internet.

Navajo weavers today prize indigenous knowledge; many use local materials in their weavings. Collectors often value the aspects of an art form that suggest traditions handed down through generations. Yet some collectors may not realize that so-called "traditional" weavers have been in touch with outside materials and markets for centuries.

D. Y. Begay uses local dye recipes and handspun fibers from her own Churro sheep as well as complex chemical dye recipes and Berga and Walstedts yarns from Sweden.[1] Historic Navajo weavers were similarly eclectic, even in the earliest times. Nineteenth-century Navajo weavings, in particular, evince a startlingly cosmopolitan use of materials—from cotton raised by the neighboring Pueblos, to the rare use of imported silks, or the common use of European wools. In the realm of dyes,

After I moved back to Arizona, I acquired some Churro sheep myself and I had some white ones and some black ones. And then I became more interested in the black Churro for the color, so what I raise today are the black Churro sheep. . . . They are a very hardy animal. They are very adaptable to any environment because my Churro winter down in southern Arizona and then during the summers I take them back up north to my home. They're very adaptable to any environment, whether it's harsh, cold, hot. . . . And the fiber itself is very clean, greaseless, very easy to clean, wash, card, spin. It's very beautiful to spin Churro wool, and the fiber tends to be long, and that's very nice for spinning.

— D. Y. Begay[3]

weavers unraveled Mexican textiles to make use of rich scarlet fibers saturated with the cochineal and lac dyes from insects made by Mexican dyers; and, like other weavers throughout the Americas, they readily adopted aniline dyes from Europe directly after their invention in the 1850s.[2]

The industrial revolution in the nineteenth century gave rise to first-rate yarn mills in Germantown, Pennsylvania (an outlying neighborhood of Philadelphia), which in turn allowed for a new direction in Navajo weaving. Navajo textiles woven

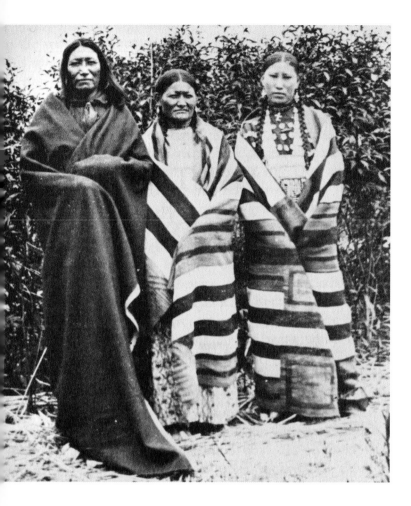

FIGURE 3.2. Spotted Tail, a high-ranking Lakota, with his wife and daughter, c. 1879. Both women wear Second Phase Chief Blankets. Photo by W. R. Cross, from George Hyde, *Red Cloud's Folk* (Norman: University of Oklahoma Press, 1976), 186.

textiles known as "eye dazzlers," because of the detail and vivid color palette that could be achieved with these fine yarns (figure 3.1). In the eye dazzler illustrated here, the weaver has demonstrated her dexterity by the way she has manipulated the complex serrated diamond and half-diamond bands of red, blue, black, white, and gold on the orange field. This requires tens of thousands of color changes during the weaving process, something that would probably not have been attempted without the labor-saving "short-cut" of having fine, strong commercially spun and dyed yarns.

All the textiles mentioned above were prized by Anglos and Hispanics alike in the nineteenth century. Indeed, in 1847, one was purchased by a U.S. Army doctor rather far afield from Navajo country—in Veracruz, Mexico![5] Numerous early commentators lavished praise on the products of Navajo women's looms, one Lieutenant Simpson proclaiming in 1852 that Navajo blankets were "the best blankets in the world!"[6] Charles Lummis wrote in 1892 that Navajo women "weave a handsomer, more durable, and more valuable blanket than is turned out by the costly and intricate looms of Europe and America."[7]

Pueblo people, from whom the Navajo had learned the art of weaving some centuries before, eagerly bought Navajo textiles in the nineteenth century. More distant Plains Indians acquired them through trade.[8] Evidence of their value on the Great Plains is found in

with Germantown yarns began as the astonishing products of the greatest adversity the Navajo have ever known—their incarceration at Bosque Redondo in the 1860s. After their return to their homeland, Germantown yarns were issued as annuity goods for several years, and after that, they were available at trading posts for another 25 years.[4] This gave rise to the virtuoso

an early watercolor by Karl Bodmer; in Kiowa, Cheyenne, and Lakota ledger drawings; and in late nineteenth-century photographs. While traveling on the Upper Missouri River with Prince Maximilian's expedition in 1832-34, Bodmer endeavored to portray the Native peoples he encountered as "untainted" by outside influence, yet he unwittingly painted a Piegan Blackfeet man wearing a striped Navajo blanket (First Phase Chief Style) and a Pueblo silver pendant—both objects of long-distance trade.[9] In one of the Lakota Winter Counts (a pictographic historical record), the winter of 1858-59 was characterized as a "Many-Navajo-blankets winter." Several sources agree that a notable influx of these prized textiles occurred at that time.[10] An 1879 photo of Spotted Tail, a high-ranking Lakota, and his family shows his wife and daughter both wearing handsome Second Phase Chief Blankets (figure 3.2).[11] For twentieth-century versions of Chief Blankets in this exhibit, see works by Grace Henderson Nez and Mary Henderson Begay (1988, Plate 1; and 2004, Plate 3).

Kiowa and Cheyenne people on the Southern Plains (who had more direct trade venues with Southwestern peoples, including the great trading fairs at Pecos and Taos, New Mexico) valued Navajo blankets too, as is evident in their ledger drawings. For example, a drawing by the Cheyenne artist Making Medicine (figure 3.3) shows an encampment in Oklahoma Territory in 1873; the two figures at the lower left wear boldly striped Navajo blankets.[12]

While Navajo women made countless blankets for use by their own people in the nineteenth century, they also participated in a larger market economy in which raw materials from Latin America, the eastern United States, and Europe, as well as fabrics of exotic dyes and manufacture, came into Navajo households. These were reworked and transformed into

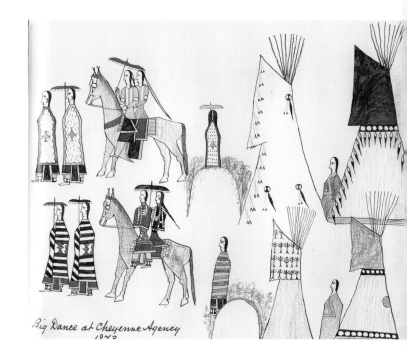

FIGURE 3.3. Detail from "Big Dance at Cheyenne Agency, 1873," drawing by Cheyenne artist Making Medicine (1844-1931), 1876. Various trade blankets worn by Cheyenne people are depicted in this drawing, including two Navajo blankets, lower left. Private collection. Photograph by J. C. Berlo, 1994.

finished blankets of extraordinary beauty that reflected a Navajo aesthetic. Weaver Irene Clark's recent acerbic observation was as true in the nineteenth century as it is today: "Whatever you white people make, we get it, and we use it!"

Similarly, in contemporary weaving, local yarns and dyes exist side by side with imported dyes and yarns (some of which are re-spun to suit the weaver's exacting standards). And Navajo textiles now feed a world market. Numerous mid-twentieth century American artists collected Navajo textiles, admiring their bold abstractions that seemed akin to the concerns of modernist painters.[13] Expert weavers, including Irene Clark, have been commissioned to weave tapestries based on artist Kenneth Noland's abstract designs.[14]

If "imitation is the sincerest form of flattery," as the saying goes, male Zapotec weavers in small villages of Oaxaca pay homage to Navajo women and the works of their looms. These home-based entrepreneurs have, for more than two decades, produced inexpensive knock-offs of Navajo textiles on their treadle looms (figure 3.4).[15] While Navajo weavers understandably object to this, it is unavoidable in a world in which images and ideas circulate globally through books, exhibition and auction catalogues, and now through the Internet. Just as hand-made American quilts have been replicated in Chinese factories for sale to those for whom "the real thing" is out of their price range, so too, Zapotec replicas of Navajo rugs provide a way for the less affluent to have a version

of what they admire.

Throughout the indigenous Americas, the late twentieth century has been a time of reasserting cultural values and native traditions. The realm of weaving is no exception. In his 1914 book, *Indian Blankets and Their Makers*, George Wharton James lamented that there were "perhaps half a dozen weavers on the whole reservation" who were conversant

FIGURE 3.4. Home workshop of the Vasquez family, Teotitlan del Valle, Oaxaca, Mexico, in which treadle-loom woven rugs of Navajo design were offered for sale along with others featuring imagery from Mexican archaeology, African rock art, and artist M. C. Escher. Photograph by J. C. Berlo, 1990.

with Native dyeing techniques.[16] Regardless of the accuracy of his numbers, James clearly thought that the use of native dyes was a disappearing art; his view was an aspect of that intransigent early twentieth-century paradigm of the "vanishing Indian." Yet numerous early scholars, from Washington Matthews onward, documented indigenous dye technology.[17] In 1940, Navajo teacher Nonabah Bryan published in the Bureau of Indian Affairs' Indian Handcraft Series a booklet containing dozens of natural dye formulas.[18]

While charts of local dye plants have long been a staple of handicraft sales,[19] the real renaissance in Native dye technology seems to be going on right now. D. Y. Begay speaks animatedly about the many plants she uses that grow near her family home in Tselani, near Chinle, Arizona: sagebrush, Navajo Tea, rabbit brush, snakeweed, dock roots, chamisa, mahogany roots, and others. She enthusiastically learns from and shares with other weavers knowledge about local plants and dyestuffs. Irene Clark talks knowledgeably about using *glot* (a ground lichen): "You boil as much as you get and then it turns real bright red, and that's the time you put the wool in with the *tsedik onge* [i.e., rock salt]. It makes it really red, and then you put the wool in. It makes other colors, too, three or four different colors."

Local dyes are used to admirable effect in many of the textiles in *Weaving Is Life*. Glenabah Hardy's *Crystal Wall Hanging* (1980, Plate 6) renders repeating geometric shapes against a banded background. Her soft colors were achieved by using Navajo Tea, lichen, sage, and dock root. Her daughter, Irene Clark, learned to use such dyes from both her mother and grandmother (1979, Plate 7; and 2005, Plate 8), and has passed the knowledge on to her own daughter, Teresa Clark (2005, Plate 9). In the age of the Internet, some weavers may learn about dyes and order exotic materials on-line, but the passing of information orally, from grandmother, to mother to daughter, continues to flourish. As of this writing, Glenabah Hardy is 95, and still weaving.

This is sage. . . . My great-grandmother was using it to dye wool. My mom was using this for her green color. So that's how I started. You have to get a whole bunch of it and boil it, and then it takes a lot of work to color all that. So if you want a real dark green, you have to make more and more, and then you boil it about three or four times until the water gets black and that means it's dark green, so for the last one you chop it up in small pieces and then put the wool in and put the salt in and stir it and stir it for maybe about thirty, forty minutes. And then, if it's real dark green, you take it out and then rinse it to make sure you like the color. So that's how it works, this one, sage.

—Irene Clark

Rooted in Place: Abstraction and Representation in Navajo Weaving

As anthropologists Steven Feld and Keith Basso have observed, there are multiple ways in which "places are metonymically and metaphorically tied to identities."[20] Though human beings render places meaningful through many means, language and art are particularly important tools by which to make particular locales resonate with deep meanings. The Navajo worldview is built upon the primacy of place;[21] the universe itself is imagined as a *hogan* (the traditional Navajo polygonal dwelling, the doorway of which faces east, toward the rising sun). Within this vast cosmological home exist many sub-sets of home. *Dinétah*, the area circumscribed by the four sacred mountains, is conceptualized as a hogan, too, its supporting posts being *Sisnaajiní* (Sierra Blanca Peak in Colorado) in the east; *Tsoodzil* (Mount Taylor) in the south; *Dook'o'oslííd* (San Francisco Peak) in the west; and *Dibé Nitsaa* (Mount Hesperus) in the north. These form a parallelogram around Navajo country.[22] While much of *Dinétah* might seem to outsiders to be a tough, dramatic wilderness, to a Navajo it represents the safety of home. This home is represented both abstractly and literally in textiles.

D. Y. Begay uses "the natural colors, and the colors that I see in my environment, which could be in the plants, in the sand, the dirt, the clay, the crevices in the cliffs and rocks. I take pictures of canyon walls,

and often times I use that as inspiration." Her textiles, *Journey* (2005, figure 3.5) and *Regional Mood* (2004, figure 3.6), were woven in successive strata of shades of black, blue, gray, and lavender. Both works recall the depth and distance of landscape and sky in *Dinétah*, and the way that the land reveals itself in long, atmospheric vistas in the Southwest. The weaver has used natural dyes to excellent effect in these two works, for the somber blues and grays vary by just a few shades.

FIGURE 3.5. D. Y. Begay, *Journey*, 2005. Natural (undyed) and vegetal-dyed handspun wool, 49 x 35 in. Collection of the Heard Museum, Phoenix, Arizona.

In Rosie Taylor's weaving, *Family Teaching* (2004, Plate 14), the multi-color bands of stripes, and the three rows of four lozenges are customary components of Navajo weaving, but here she alternates these abstract designs with two rows of four *hogans* (one for each of the four directions?), making the viewer want to read the textile as a landscape of layered bands of rock of the type that one can see in many parts of *Dinétah*. One might further interpret this as a tribute to home, or a longing for home. On the topic of home, Rosie Taylor has observed,

> The spirit in me keeps coming back [to the Navajo Reservation]. . . . The open spaces. Having sheep, goats, cattle around me. And that's what I really like. . . . They used to tell us, 'you have to know what clan you are.' They say when you go someplace,—even if you are in New York—if you come across a Navajo person, you ask them what their clan is. Sure enough, if they say they are *Kinyaa'áanii* clan, they are absolutely related to you. So this is how you have relatives. You are not alone out there. Even if you go outside the four sacred mountains, it always brings

Even those textiles that may seem abstract to the casual viewer may evoke multiple meanings on the part of a Navajo weaver or a Navajo audience. Paul Zolbrod has observed that, to an outsider,

FIGURE 3.6. D. Y. Begay, *Regional Mood*, 2004. Natural (undyed) and vegetal-dyed handspun wool. 26 x 33 in. Collection of Center of Southwest Studies, Fort Lewis College, Durango, Colorado.

a Navajo textile may seem to be a mute design, but that to most Navajos "rugs are full of meaning derived from stories heard, ceremonies attended, and firsthand information obtained within the framework of a world view widely shared by people who maintain their individual perspectives in the context of a shared past;" moreover, he suggests that for a Navajo audience, a textile should "invoke knowledge and arouse questions" such as "at what point does a seemingly abstract design designate a story or connect with land and skyscape?"[23]

One of the youngest weavers in *Weaving Is Life*, Gloria Begay, has produced a masterpiece of elegant simplicity in *Dawn Meets Dusk* (2005, Plate 4). It is abstract as well as representational. At the bottom, a horizontal band of mother earth supports the sky, depicted in the transitional times of day, dawn and dusk. On the grey sky of dusk, at left, the stars stand out more vividly than they do in the sky of dawn, at right. A

vertical band divides the two color fields. The emphatic triangle at bottom center represents an individual as the center of the universe.[24] Whether admired as work of bold, graphic simplicity, or a statement about Navajo metaphysics, this textile stands as an eloquent work of art.

While *Weaving Is Life* is not focused on the sizeable collection of sandpainting textiles in the Kennedy Museum of Art, I include one here to illustrate the interplay between abstraction and representation

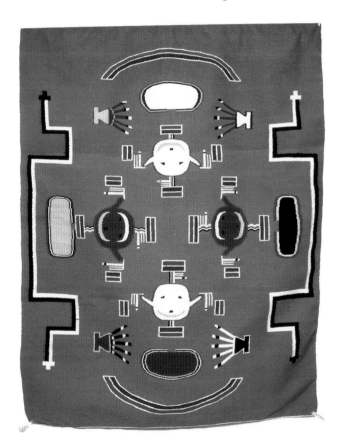

FIGURE 3.7. Grace Joe, *Mountains of the Sun and Moon from the Hail Chant*, 1970. Wool. 46.25 x 48 in. Edwin L. and Ruth E. Kennedy Southwest Native American Collection, Kennedy Museum of Art, Ohio University, KMA 91.023.392.

in Navajo textiles (figure 3.7). Just as weavers have long depicted imagery from outside their culture in weavings (such as the American flag, or the railroad), so too have some weavers drawn upon the most important pictorial imagery within their culture—the ephemeral sandpaintings done by male ceremonial practitioners.[25] Grace Joe, of Red Valley, Arizona, has replicated a sandpainting called *Mountains of the Sun and Moon from the Hail Chant*, that

I was a very young child, very young. I became aware of weaving, and even at that young age I also took care of the sheep. That was my job. That's where I learned how to shear. I learned how to work with the wool, and my mother used to card. I used to want to do the same thing she was doing, and this is how I learned to weave. I just watched her. She did the carding and spinning, and I learned by watching her. That's when I started to learn about weaving. My mother asked me to card the wool. "This is how you do it." That's how I learned to do the carding, and then spinning came. I learned how to spin. At first it wasn't easy. And the warps, the warping process was the next step. She used to show me how to do it, and I just observed. And I wanted to do it, too, and I tried it, and I did some warping. And this is how it started. Sometimes I spun, and I got to do it more and more, and I did small weavings, and they were often just stripes or bands.

— Lillie Taylor

was first recorded by Hastiin Klah and Franc Newcomb more than seventy years ago (1970, figure 3.7).[26] Here, the weaver's ingenuity comes into play in the way she is able to translate imagery from another medium into the rigorous horizontal and vertical format of warp and weft. Features of landscape and cosmos are given semi-abstract, yet recognizable form. Grace Joe has rendered the four sacred mountains of *Dinétah* (discussed above) in black, blue, yellow, and white, each guarded by a horned sun (blue) or moon (white). Softly curving rainbows guard the north (white) and south (blue) mountains, while rectilinear forms of black and white lightning guard the east (black) and west (yellow) mountains. The same aesthetic preference for dynamic symmetry and repetition within variation seen in other textiles (discussed further below) is evident in this magnificent tapestry.

Aashi bi'bohlii: "It's up to you": Individuality and Creativity in Navajo Culture

> *There is a Navajo phrase,* aashi bi'bohlii, *which means, "It's up to you." When my mother uses this term, she is saying that there are no formulas in weaving. Weaving allows us to create and to express ourselves with tools, materials, and designs.*
>
> — D. Y. Begay[27]

Navajo culture has been characterized as far more individual and less communal than many other Native American cultures, especially those of their close neighbors the Hopi, Zuni, and other Pueblo peoples.[28] Individual autonomy is valued, and people generally do not attempt to speak for, or make decisions for, another. Perhaps this accounts for the fact that Navajo weaving, originally learned from Pueblo weavers some three or four centuries ago, has far outstripped Pueblo weaving in terms of creative use of materials, techniques, and design possibilities. Navajo creativity has long involved a selective adaptation of traits found useful. For this reason, it has proved to be endlessly inventive, both in materials and in aesthetic decision-making. Gary Witherspoon has phrased it most succinctly:

> In Navajo weaving we see a technology learned, developed, and improved to a degree that none of their neighbors could match. We see an art form, used in the eighteenth century to make blankets, clothing, and saddle blankets for their own use, transformed into a barter item by which they were able to acquire tools and other technology in the latter part of the nineteenth century, and then transformed again into a cash-producing art form in the twentieth century. Through all these times and conditions, weaving was used to serve not only the aesthetic and cultural needs and purposes of the Navajo, but also their economic

43

ones. This ability to synthesize aesthetics with pragmatics, internal cultural expression with external market influence, individual creativity with universal culture theme, is at the very heart of their vigor, vitality, and adaptability as a human society.[29]

The imperative to create beauty (*hózhó*) in the world is fundamental to Navajo philosophy and rightful living. Weavers create beauty by harmoniously bringing together many strands of nature and culture.[30] Materials from the world of plants and animals are transformed through human dexterity, artistry, and intellect; cosmopolitan and local worlds come together in the creative synthesis of materials of diverse manufacture and images from many sources.

Just as the beautiful and ever-changing terrain of Navajo country has inspired many textiles, the dye pots of grandmothers have caused some young artists to want to create beauty, too. D. Y. Begay shares an evocative image of her paternal grandmother, Despah Nez:

> I think she is the person that really opened my eyes to colors, colors we use in our weaving. I always refer to her as "magic hands" because at one point when I was very young, she was dyeing yarn and she pulled the yarn out of the pot and there were these vibrant, brilliant colors. I just didn't understand how she

got those colors, so I called her "magic hands." I always remembered that, and I think it really made a big impact on my weaving.

Contemporary Navajo painter Emmi Whitehorse has similar memories:

> My grandmother is the one that raised me. One of the things that impressed me the most was when she would dye the wool. It would be this magnificent blood red. She would take a stick and draw the wool out of the boiling vat, and she would hang it up—just seeing this in the sun. And then later in the day it would change to a more earthy red. Red is so emotional—it holds so much human emotion, that color. From her, I use a lot of red.[31]

"Dynamic symmetry" is the chief aesthetic principle in Navajo textiles; beyond this, repetition, alternation, movement and contrast combine to give a weaving what Gary Witherspoon has called "a visually energized surface."[32] Contemporary weavers sometimes seem to strive for precise symmetry (see, for example, Plate 12, Lillie Taylor's *In the Path of the Four Seasons*), while the dynamic symmetry characterized by "subtle variations that produce a broadly balanced impression of symmetry"[33] are most often seen in historic examples. Yet, Lillie Taylor's *Multi-Pattern Four-In-One* (1975, Plate 11), by its use of four different designs, illustrates these principles. The

designs in the upper left and lower right are framed by a white stepped pattern, while those in the lower left and upper right are framed by solid white bands. Moreover, Taylor's use of earth colors, while balanced, is not rigidly so.

A Navajo weaver's creativity can be expressed in the absolute graphic simplicity of D. Y. Begay's *Two Points* (2005, Plate 19) or in the dazzling complexity of Lillie Taylor's four-in-one, mentioned above. The latter shows off the weaver's virtuosity as well as her limitless patience with the multiple weft colors that are constantly in play.

The familial terms that many weavers use to describe their looms and their textiles suggest a deep and abiding kinship with this quintessentially female art form. Lillie Taylor observes that "weaving is like your mother." Many other weavers say that the products of the loom are like their children.[34] Irene Clark has described the joy of seeing one of her weavings from decades past in the Kennedy Museum collection: "This is good. It is like you saw a friend, a relative. This is how I feel [making a movement of touching herself in blessing]. It's great. I'm glad you have this displayed. It is good. Take care of it. I am happy. I am glad to see it again."

Such sentiments reflect the deeply felt love that Navajo weavers have for all aspects of their work—from the acts of dyeing and weaving, to the learning process that links them to their female forbears and to the land, to the products of the loom that they send out into the world—a projection of the *hózhó* that each individual is meant to embody and create.

Anyone who has grappled with painting, sculpture, quilt-making, or any other art form understands Rosie Taylor's comment that "when I sit down and start weaving, it totally changes the design . . . the weaving itself . . . it starts creating its own design." But perhaps in its succinctness, the most insightful observation is Irene Clark's: "Our designs are our thinking." These words are a tribute to artists everywhere who want the world to know that not only is art-making hard work, but it is a cerebral undertaking. In *Weaving Is Life*, we see the deepest thoughts of Navajo weavers displayed for our joyful admiration—and we are grateful.

Acknowledgments

I am grateful to Jennifer McLerran for asking me to contribute to this catalogue, and for her generosity in sharing the files of the Kennedy Museum as well as her own wide-ranging knowledge for this and other projects. I am honored to be in D. Y. Begay's company in this volume. In 1987, I took a one-day Navajo spinning workshop with D. Y. at the Textile Museum in Washington, D. C., and have admired her artistry, her vast knowledge, and her enthusiasm for sharing that knowledge ever since.

Author's Biography

Janet Catherine Berlo is Professor of Art History and Visual and Cultural Studies at the University of Rochester in western New York. She is the author of numerous books on Native American art history and textile arts, including *Native North American Art* (with Ruth Phillips, Oxford, 1997), *Spirit Beings and Sun Dancers: Black Hawk's Vision of a Lakota World* (Braziller, 2000), *Wild By Design: 200 Years of Innovation and Artistry in American Quilts* (with Patricia Crews, Univ. Washington Press, 2003), and *Textile Traditions of Mesoamerica and the Andes* (with Margot Schevill and Ned Dwyer, Univ. Texas Press, 1996).

Notes

[1] D. Y. Begay, "*Shi' sha' hane'* (My Story)", in *Woven by the Grandmothers*, ed. Eulalie Bonar (Washington, D.C.: Smithsonian Institution Press in association with the National Museum of the American Indian, Smithsonian Institution, 1996), 22-23.

[2] Joe Ben Wheat's magisterial posthumous volume, *Blanket Weaving in the Southwest*, ed. by Ann Lane Hedlund (Tucson: University of Arizona Press, 2003), chapters 2-4, meticulously documents the use of trade materials in Navajo weaving from 1598-1900.

[3] Unless otherwise noted, all references to statements by the weavers whose works are in the Kennedy Museum derive from interviews conducted by Jennifer McLerran and D. Y. Begay in 2003 and 2004, and from a lecture given by Begay at the museum in 2004. Transcripts are on file at the Kennedy Museum.

[4] Joe Ben Wheat, *Blanket Weaving in the Southwest*, 52-54.

[5] Ann Lane Hedlund, *Beyond the Loom: Keys to Understanding Early Southwestern Weaving* (Boulder, CO: Johnson Books, 1990), 58.

[6] J. H. Simpson, *Report on the Navaho Country, 1852*, as quoted in George Wharton James, *Indian Blankets and Their Makers* (1914; reprint, New York: Dover Publications, 1974).

[7] Charles Lummis, *Some Strange Corners of Our Country: The Wonderland of the Southwest* (New York: The Century Company, 1892), 198.

[8] See Joe Ben Wheat, "American Indian Weaving: Early Trade and Commerce Before the Curio Shop," *Oriental Rug Review* 8, nos. 4 and 5 (1988).

[9] For illustration, see J. C. Berlo and Ruth Phillips, *Native North American Art* (Oxford: Oxford University Press, 1998), figure 18.

[10] Garrick Mallery, *Picture-Writing of the American Indians*. Vol. 1 (1893; reprint, New York: Dover Publications, 1972), 325. This is from Battiste Good's winter count. Notably, in Lone Dog's winter count, 1853-54 was characterized as a winter in which a white trader brought many "Spanish" (i.e., Mexican) blankets (283), suggesting that the Lakota distinguished between these two textile traditions, both of which were exotic imports to the Northern Plains.

[11] A First Phase Chief Blanket (c. 1840-50) in the National Museum of the American Indian was collected by artist DaCost Smith while he traveled and painted among the Sioux in 1884. See Eulalie Bonar, ed. *Woven by the Grandmothers* (Washington, D.C.: Smithsonian Institution Press, 1996), plate 21, and pages 128, 187. DaCost Smith recounted his travels among the Lakota in *Indian Experiences* (Caldwell, Idaho: Caxton Printers, 1943). The Sioux owner of this blanket transformed it according to local custom by attaching brass and German silver buttons, quill-wrapped cords, horsehair and tin ornaments. Moreover, there is some visual evidence that a local beaded blanket strip of the kind normally seen on Northern Plains hides and blankets had been attached to it at one time.

[12] A Navajo blanket of extraordinarily complex design, dating from before 1864, was a valued possession of the Cheyenne chief White Antelope. It is made of silk (an unusual material in Navajo weaving), as well as fine wool yarns colored with synthetic dyes (School of American Research Collection, Santa Fe, # T.43). Its central diamond pattern suggests the influence of Saltillo sarapes. See Kate Peck Kent, *Navajo Weaving: Three Centuries of Change* (Santa Fe: School of American Research, 1985), 36 and Plate 2.

[13] Tony Berlant and Mary Hunt Kahlenberg, "Blanket Statements," *Art News* 71 (Summer 1972): 42-50.

[14] See Ann Lane Hedlund, *Reflections of the Weaver's World* (Denver: The Denver Art Museum, 1992), 40-41.

[15] See Lynn Stephen, "Export Markets and Their Effects on Indigenous Craft Production: The Case of the Weavers of Teotitlan del Valle, Mexico," in Margot Schevill, Janet Berlo and Edward Dwyer, *Textile Traditions of Mesoamerica and the Andes* (Austin: University of Texas Press, 1996), 381-402. In that same volume, my own article, "Beyond Bricolage: Women and Aesthetic Strategies in Latin American

Textiles," 437-79, discusses cross-cultural strategies of appropriation in ethnic textiles.

[16] James, *Indian Blankets*, 66.

[17] See, for example, Washington Matthews, "Navajo Weavers," *Bureau of American Ethnology Third Annual Report* (Washington DC: The Smithsonian Institution), 1998, 376-77; James, *Indian Blankets*, Chapter 11; Gladys Reichard, *Spider Woman: A Story of Navajo Weavers and Chanters* (New York: Macmillan, 1934), Chapter 34.

[18] Nonabah Bryan, *Navajo Native Dyes*. Indian Handcraft Series, #2 (Washington DC: U.S. Office of Indian Affairs, 1940).

[19] In the film *A Weave of Time: The Story of a Navajo Family, 1938-1986* (Los Angeles, Direct Cinema, Ltd., 1987), Isabel Burnside Deschinny recalls earning a living making dye charts for sale and weaving while her husband was a law student in Washington, D.C. from 1972-75.

[20] Steven Feld and Keith Basso, introduction to *Senses of Place*, ed. by Steven Feld and Keith Bosso (Santa Fe: School of American Research, 1966), 11.

[21] A highly developed sense of place is one of the features of most cultures of aboriginal America, yet a sense of place may be particularly well-developed among Athapaskan peoples, of which both the Navajo and neighboring Apache are a part. See, for example Keith Basso, *Wisdom Sits in Places: Landscape and Language Among the Western Apache* (Albuquerque: University of New Mexico Press, 1996); Robert McPherson, *Sacred Land, Sacred View: Navajo Perceptions of the Four Corners Region* (Salt Lake City: Brigham Young University, 1992).

[22] See Laura Gilpin, *The Enduring Navaho* (Austin: University of Texas Press, 1968), 10-19, for aerial photos of each of the sacred mountains.

[23] Roseann Willink and Paul Zolbrod, *Weaving a World: Textiles and the Navajo Way of Seeing* (Santa Fe: Museum of New Mexico Press, 1996), 80 and 98.

[24] The interpretation of this textile derives from a conversation between curator Jennifer McLerran and the weaver (Gloria Jean Begay, telephone conversation with Jennifer McLerran, February 6, 2006).

[25] Some of the weavers who do this are the wives or daughters of chanters. A full discussion of this phenomenon is beyond the scope of this brief essay. See Jennifer McLerran, "Woven Chantways: The Red Rock Revival," *American Indian Art Magazine* 28, no. 1 (Winter 2002): 64-73. Some of the sandpainting textiles in the Kennedy Museum collection were first published in Frederick Dockstader, *The Song of the Loom: New Directions in Navajo Weaving* (New York: Hudson Hills Press, 1987). For a survey of pictorial weavings of all sorts, see Tyrone Campbell and Joel and Kate Kopf, *Navajo Pictorial Weaving 1880-1950* (New York: Dutton Studio Books, 1991).

[26] The pictorial source for this tapestry was Mary C. Wheelwright, *Hail Chant and Water Chant* (Santa Fe: The Museum of Navaho Ceremonial Art, 1946), 179. See also pp. 26 and 178 for the explication of its imagery.

[27] D. Y. Begay, "*Shi' sha' hane'*," 25.

[28] See, for example, Ruth Underhill, *The Navajos* (Norman: University of Oklahoma Press, 1956); Clyde Kluckhohn and Dorothea Leighton, *The Navaho* (Garden City, NY: Anchor Books, 1962).

[29] Gary Witherspoon, *Navajo Weaving and Its Cultural Context* (Flagstaff: Museum of Northern Arizona, 1987), 4.

[30] See Gary Witherspoon, "Self-esteem and Self-expression in Navajo Weaving," in *Tension and Harmony: The Navajo Rug*, special issue of *Plateau Magazine* 52, no. 4 (1981): 28-32. For Navajo aesthetics, see also his *Language and Art in the Navajo Universe* (Ann Arbor: University of Michigan Press, 1977), chapter 4.

[31] *Emmi Whitehorse*, video (Santa Fe: The Wheelwright Museum, 1991).

[32] Witherspoon, *Language and Art in the Navajo Universe*, 166-72.

[33] Willink and Zolbrod, *Weaving a World*, 30.

[34] Loretta Benally, in Willink and Zolbrod, *Weaving a World*, 33. For similar sentiments among Maya weavers in Guatemala, see Berlo, "Beyond Bricolage," 443-47.

D. Y. Begay

Weaving Is Life: A Navajo Weaver's Perspective

Iina' is an extraordinary Navajo word that describes how you live, how life is carried out, and how life is respected in the Navajo world.

Weaving is iina'. *Weaving is a way of life, it is beautiful, it is our thinking, it secures our well being, it consoles our feelings, and it perpetuates our Navajo traditions and womanhood.*

"This is what you call iina'.*"*

Weaving Is Life: Development of an Idea

In November 2003, I was invited to examine the unique and comprehensive Edwin L. and Ruth E. Kennedy Southwest Native American weaving collection housed in the Kennedy Museum of Art at Ohio University. Since I have a passion for textiles, it would have been impossible for me to pass up the invitation, and I immediately accepted. I knew this would be an extraordinary opportunity for me to learn about a collection in which the majority of the weavings are seldom seen by the public, no less by Navajo weavers. I also realized that this was a perfect chance for me to get my foot in the door to explore this exceptional assortment of work and to have a voice in how it might be best displayed.

I was enthralled with the textiles in this major collection, which includes some of the most rare and distinctive sandpainting designs incorporated into Navajo rugs. There are nearly 100 sandpainting weavings in the Kennedy Museum's collection depicting sacred design elements and images from various healing ceremonies. It is perhaps the largest single collection of sandpainting textiles in existence.

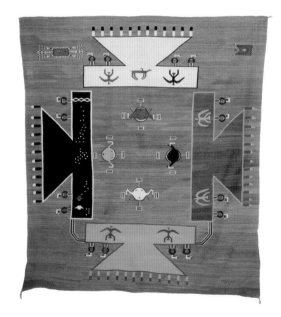

FIGURE 4.1. Hastiin Klah, *The Skies from the Shooting Way Chant*, 1937. Wool. 110 in. x 123 in. Edwin L. and Ruth E. Kennedy Southwest Native American Collection, Kennedy Museum of Art, Ohio University, KMA 91.023.172.

The grand prize of the collection is a sandpainting weaving woven by the late Hastiin Klah (1867-1937). This weaving (1937, figure 4.1), which was Klah's last work, took my breath away. I have examined many sandpainting rugs in many museums across the country, but Hastiin Klah's rug is aesthetically and technically superb. His work illustrates an enormous beauty in form and in spirit.

I also had a personal mission to survey the rug collection for inspiration and in hope of discovering something rare or unusual. Uncharacteristic weaving techniques, designs or even symbolism are sometimes unveiled only by another weaver's eyes.

While examining the collection, the museum curator asked me for suggestions on the best way to exhibit these textiles. After viewing an enormous number of beautiful weavings, I was captivated by three names: Mary Henderson Begay, Irene Clark, and Lillie Taylor. Each of these women have handsome pieces in the collection and are still actively weaving Navajo rugs today. In addition, they all have mothers and daughters who are weavers.

I began to formulate ideas about bringing together the three generations of

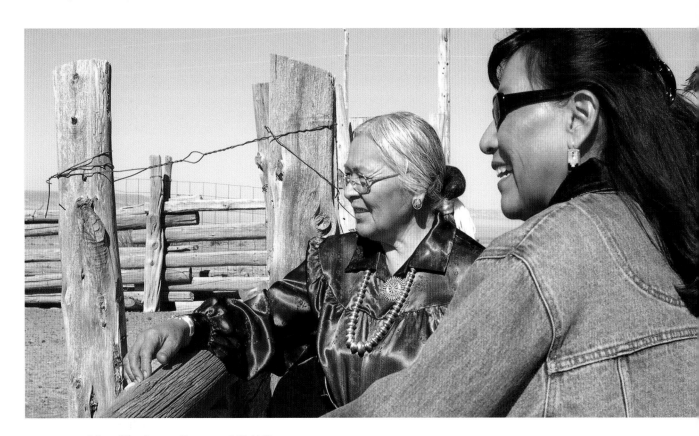

FIGURE 4.2. Mary Henderson Begay and D. Y. Begay at Mary's sheep corral, Ganado, Arizona, 2004. Photograph by Sally Delgado.

49

weavers from these three families. These women are all prominent weavers who have distinctive and superb weaving skills. They are the bearers of the Navajo weaving tradition, and I believe that the weavers themselves can best present their stories in their own voices. By bringing these weavers together to present their own stories in their own voices, the Kennedy Museum creates an opportunity for Navajo weavers to access the museum world to explore its possibilities and to share their talent with others.

The exhibition *Weaving Is Life* originated with these notions. This presentation of the textiles and the stories of three families of weavers offers a history of Navajo rugs, along with a technical analysis of the origins of the colors, designs, techniques and other facets of Navajo weaving culture.

K'é:
Navajo Relational Identity

In Navajo culture *k'é* is your identity. *K'e'* gives you a sense of who you are and how you relate to your family, friends, and community. To a Navajo, *k'e'* is extremely important.

Each one of the weavers represented in *Weaving Is Life* is related to me by Navajo clan in one way or another, either as a grandmother, mother, sister or daughter. The three families included in the exhibition come from some of the major clans: the *Tábaahi Dine'*, *Haastlhii*, *Kinyaa'áanii*, *Totsoni*, and *Ma'iideeshgiizhnii*

people. I myself am born to the *Totsoni* people.

We identify our relationships with others by using our clans. For example, during the interview process, Glenabah Hardy announced that, "I am a *Totsoni*, so you are my daughter."

Based on our clanship relation, I have developed a unique connection with each of the weavers and acknowledge each one of them as a member of my family. This means I will never be alone, I will always be able to talk with someone somewhere. On any day, I am always welcome to visit any of these women and have coffee or talk about the progress of a weaving project.

FIGURE 4.3. D. Y. Begay consults with Navajo weavers (left to right) Lillie Taylor, Diane Taylor Beall and Rosie Taylor in Lillie's Indian Wells, Arizona home, 2004. Photograph by Sally Delgado.

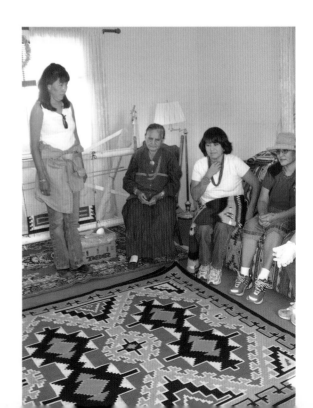

Gathering the Weavers' Stories

The video interview process was conducted in the Navajo language so that the weavers could best tell their stories. The decision to use our language, Navajo/ *Dine' bizaadi*, for the interviews was very gratifying. Not only is our language beautiful and descriptive, but also only Navajo words can convey an accurate and true picture of why we weave. Personally, when I speak in Navajo I am most comfortable and feel I am best able to manipulate the words to describe my experience with the loom, the yarn, and designs.

Speaking Navajo allowed a comfortable territory to express our ideas, our emotions, and our stories. Sometimes making a statement or expressing a specific concept is best achieved in Navajo; and, in some interviews, Navajo was the only language spoken.

I believe that to achieve a first rate and accurate representation of these artists, it is crucial to allow Native voices to tell their own stories. I honor the importance of allowing the weavers behind the looms to communicate what is most important to them, to their families and their beliefs.

The organization of the questions asked in the interviews unfolded in a natural and comfortable order. For example, in the Navajo way, we first explain who we are, what our clans and relationships are, and then address the questions. I believe this approach to the interview process allowed for a true and valuable Navajo aesthetics.

FIGURE 4.4. Ohio University Telecommunications students videotape D. Y. Begay in conversation with Glenabah Hardy and Irene Clark in Irene's home, Crystal, Arizona, 2004. Photograph by Sally Delgado.

The museum film crew visited each weaver in her own natural environment. These locations ranged from a small traditional hogan located in the high desert of northern Arizona to a more modern adobe situated near a parched mesa.

I have learned so much from interviewing all the weavers, even though I am also a weaver. The conversations with each family covered many facets of how each weaver learned to weave, how she observes weaving traditions, how she fits into her community and the importance of preserving the weaving customs and passing this knowledge on to the next generation.

I'm especially thankful for the lessons and stories from the grandmothers. They shared what they learned from their mothers and stressed how important it is to pass on this knowledge to their children and other weavers.

One of the most important things you can do in a project of this nature is to stress that the artisans and their people, their culture—whether it's Navajo, Hopi, Pima—are still alive today. Although many live on reservations in traditional housing, many live in homes just like you. They eat the same foods, attend school, have families, like anybody else in this world.

The one element that often sets Native peoples apart is the strong affiliation to their culture. This culture is still an essential part of life; and, for many, their Native language is still very prevalent. I am bilingual. Navajo is my

first language, and I switch back and forth from Navajo to English.

Weaving Is Life adheres to the goal of Edwin Kennedy to use his extensive collection of Navajo textiles as an educational tool to perpetuate Navajo weaving traditions. The Kennedy Museum of Art enthusiastically embraced the idea of using Native people in the planning and decision making to ensure that the exhibition accurately tells the stories of the weavers, using their words, their voices.

This productive collaboration between non-Native museum art specialists and Navajo weavers is a natural bridge for research, teaching, and passing on the knowledge and significance of these historical weavings.

The exhibition will provide a valuable resource for the study of Navajo traditions by students, scholars, visitors, and other weavers. In a more aesthetic sense, the textiles on display should simply be enjoyed, admired, and studied for their beauty, for their various uses, and for their cultural significance.

Examples of the special knowledge and information these weavers possess have been gathered in conversations and interviews. I am grateful that we have been able to bring together for future reference some of the weavers' intrinsic ideas and guiding forces that have never been formally recorded or written down.

I know first hand that many Navajo weavers are very excited about the rugs in this collection. They are interested in learning the history of how these weavings came into the museum's possession and the role Mr. Kennedy played in establishing this resource.

The weavers want to examine the individual pieces closely to determine weaving structure, content, and design. This close contact will allow for Navajo aesthetics and will provide additional valuable knowledge and stories about the rugs.

Our weaving traditions have lives, they have special qualities that invoke mindful tasks to create unthinkable lines, shapes, and colors. *Weaving Is Life* will be instrumental in documenting these traditions for future generations.

FIGURE 4.5. D. Y. Begay examines weavings in the Kennedy Museum of Art's Edwin L. and Ruth E. Kennedy Southwest Native American Collection in preparation for *Weaving Is Life* exhibition, 2004.

"Where I'm from..."

Diane Taylor Beall

I am from within the Four Sacred Mountains upon the Navajo Reservation, where Mother Earth is still considered the giver of life. As the seasons change, so do the hands of my mother Lillie, as she weaves the patterns upon the blue metal upright vertical loom with knots and bolts to strengthen the tension of her loom.

I am from a long line of weavers known for a unique style of weavings. I come from the plateaus where the rich herbs and roots of the juniper flourish. Rabbit- and sage-brush sway from side to side and the aroma of the sweet Navajo Tea fills the air as if they are shouting for joy. They are all used to bring the natural beauty to our weavings.

I am also from Two Point Canyon in Indian Wells, Arizona, where my feet and umbilical cord were planted like seeds so that some day I may walk in the path of my mother's footsteps. There I am also surrounded by the sounds of the bluebirds reminding me of the blue corn meal that my grandma made for me as a child.

I am also from the east where the sun rises gently to give light upon Mother Earth. As the sun rises upon the plateau, the shadows of juniper trees reveal the essence of the inner spirit awakening to a new dawn. This is when I hear the sounds and voices of the "Holy People," as my father Carl gives offerings to the deities with a sprinkle of the yellow corn pollen from his leather medicine pouch.

I am also from a place where I hear loud jet airplanes passing right above my home on a daily basis, where cars and trucks rumble and rush down the street from all directions, where sirens roar from the fire trucks and police cars in the middle of the night, keeping me awake as the night lingers on. But within the four walls of my home I have security, respect, love and understanding of my inner spirit where there is beauty all around me.

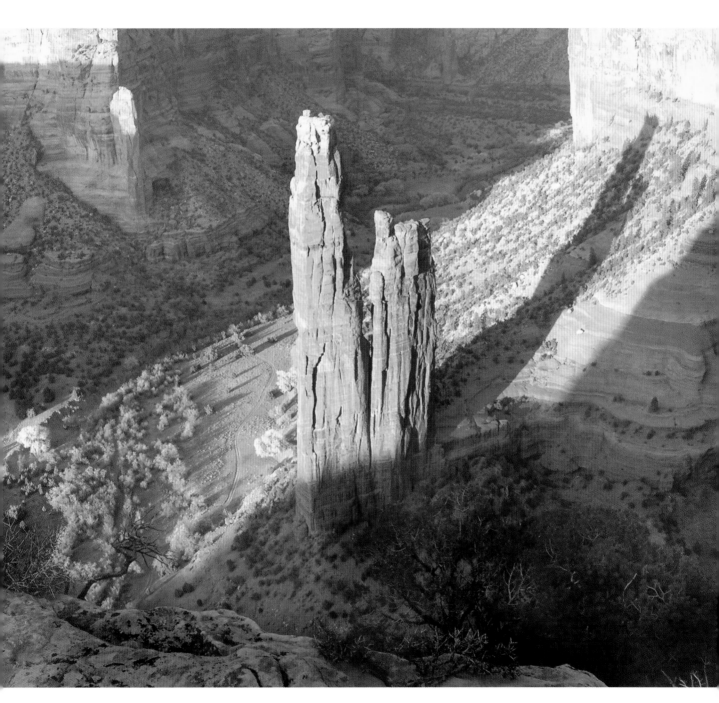

FIGURE 5.1. Spider Rock, Canyon de Chelly,
Arizona. Photograph by Tom Patin.

From Sheep to Loom: A Museum Educator's Perspective

Sally Delgado,
Curator of Education,
Kennedy Museum of Art

I think this is really good we're telling you this, our history of the weaving with our grandmothers and our mothers. . . . And we want our kids to go on with it. We want them to learn what it really means.

—Irene Hardy Clark, 2004

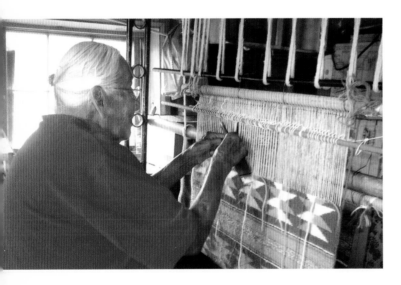

FIGURE 6.1. Glenabah Hardy weaving in her home, Crystal, New Mexico, 2004.

This statement by Irene Hardy Clark, more than any other made during the two years of consultations and interviews for the *Weaving Is Life* exhibition, became the driving force for the content of the educational galleries and programs. The Navajo weavers represented in *Weaving Is Life*, along with their families, made a conscious decision to share their personal stories and their history as Navajo women and as weavers. In doing so, they affirmed their commitment to perpetuating the knowledge and practice of weaving within their own families and culture, while at the same time affording us a glimpse of "what it really means."

One of the distinctive features of the working process engaged in by the Kennedy Museum of Art is the level of collaboration between the curatorial and the education departments. Small gallery spaces called "Education Galleries" are developed and designed in conjunction with main exhibitions, and content development is addressed with the same care in reflecting first voices rather than museum interpretation.

It is challenging to interact with objects that are laden with spiritual content, historical significance, and personal meaning – and, as a museum educator, to do so in a manner that respects

cultures and individuals, both from the viewpoint of the makers of the objects (the Navajo weavers) and the standpoint of the viewers of the objects (in this case, a primarily non-Native audience). In working with Navajo weavings within the context of school programs for a non-Native audience, another distinct dimension in the transcultural process of meaning construction comes into play. Museum educators frequently succumb to the notion of finding common meeting ground (between visitor knowledge/ experiences and museum object) on which to explore an object as a way to understand that object and, by association, a culture other than one's own. While this works to establish a dialogue, and can prove to be a meaningful experience with an object for the visitor, the results can also sway an educator into becoming less of a facilitator and more of a "fact giver." When dealing with materials that curator Jennifer McLerran refers to as functioning in part as "carriers of cultural belief [and] signifiers of cultural history and cultural identity," it is particularly challenging to find the correct balance between the role of facilitator and that of conveyor of information.

When considering object-based learning methodologies with the exhibition *Weaving Is Life*, the central question the museum addresses is: What do the weavers themselves want to convey – about their weavings, about themselves, about their culture? In the months leading up to the opening of the exhibition, even as the weavings became personified in the midst of highly personal and meaningful stories and experiences – past and present – one of the key concepts that every weaver returned to was the process of weaving itself. For each of them, the physical process is slightly different. D. Y. Begay raises Churro sheep, shears them with hand shears, cards and

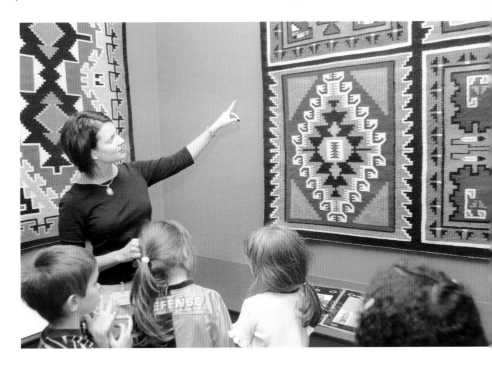

FIGURE 6.2. Kennedy Museum of Art Graduate Assistant, Cara Williams, conducting a school tour through *Weaving Is Life* galleries, 2005. Photograph by Rick Fatica.

spins the wool with a hand spindle, and creates her own dyes from natural sources. The Clarks no longer raise sheep but create all their dyes from natural sources. Mary Henderson Begay uses a combination of natural handspun yarn and commercial yarns and dyes. The Taylor family also uses a variety of materials, including plants that are considered sacred by the Navajo and were used for healing by their husband / father, who was a ceremonial practitioner.

Each weaver speaks at length of her own process of learning to weave, from the young child's task of sorting through the wool, to the challenge of weaving straight lines that do not form an hourglass shape on a loom warped by her mother or grandmother, to the skill of learning to warp the loom herself. As each woman talks about developing her thinking and about learning patience, the ways in which the production of meaning and cultural identity are integral to weaving practices become apparent. The connections to a rich oral history are intertwined with personal meaning-making, and the process of weaving is understood in a manner that transcends the back-breaking labor, the tedious repetition, the endless hours of sampling dye baths or of sitting in a single position. While this is understood from the viewpoint of the older generation of weavers, who not only have honored this activity but have put children through college with it, it is significant for visitors to access the viewpoint of one of the younger weavers, Gloria Jean Begay. This weaver clearly demonstrates the weight

of a sense of responsibility to both her mother and her own daughter, as well as her feelings regarding the relevance and significance that weaving holds for her as an individual.

Visitors of all ages respond to the weavings on the level of appreciation for the sheer beauty of the objects and a respectful gut feeling that the making of these objects must have been a very time-consuming activity. They want to know how long it took to make one of the weavings. Breaking down the number of hours that go into a single weaving results in the staggering realization that if value is equated to dollar amount received divided by number of hours worked, the act of weaving could not be considered particularly lucrative. A basic understanding of the Navajo weaving process, from sheep to loom, became an integral part of the experience of the exhibition *Weaving Is Life*. It became the basis for a hands-on gallery space and for museum outreach materials. It drove an education curator to take the first few feeble steps in learning to weave on a Navajo loom.

The next visitor response tends to be: What do the shapes and designs in the weavings *mean*? Often there is a desire, on the part of the viewer, to see the shapes as symbols that access their own set of understood signifiers. The assumption also exists that the designs being viewed reflect a common meaning shared by all Navajo. The complexity of regional design evolution coupled with

personal innovation and market influences, while central to a full understanding of the weavings, involves an element of time and/or prior knowledge to explore. In order to access a general understanding of what the weavings mean to a non-Native audience, analogies are drawn to various things that would be commonly understood: the materials come from living things (sheep and plants), a set of skills is passed down from mother to daughter, Navajo traditions flourish, the Navajo language is preserved, and Navajo culture is perpetuated.

Ultimately, we return to what the weavers tell us: what the weavings *mean* is life itself. Life is seen in Lillie Taylor's newborn twin sheep, and in her granddaughter Twyla's dedication to adapting the steps of the weaving process to a left-handed orientation. It is life as seen in Grace Henderson Nez's desire to continue weaving, even though her hands and eyes can only create small weavings now, and in her granddaughter Gloria's will to turn weaving into an activity that she can enjoy with her own daughter instead of the chore she remembers as a child. It is life as seen in D. Y. Begay's tireless

commitment to preserving the old ways as a means to achieve new ways. It is life as seen by the oldest weaver in the exhibition, Glenabah Hardy: "Here, my daughter, I'm thankful that she learned how to weave. She took my place. She's taking my position now. And she is a beautiful weaver." And it is life as seen once again in a disarmingly simple statement by Glenabah's daughter, Irene Hardy Clark: "Forever I will remember my mother. I'm going to continue weaving. I'm a daughter, and I want my daughter to learn. I want my grandkids to learn."

FIGURE 6.3. Sheep in Mary Henderson Begay's corral, Ganado, New Mexico, 2004. Photograph by Sally Delgado.

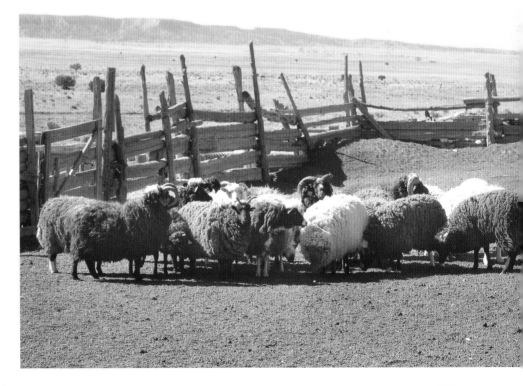

Plate 1

Grace Henderson Nez
Modified Ganado Chief Style Weaving, 1988
natural (undyed) and aniline-dyed commercial wool
72.5 x 46 in.
Edwin L. and Ruth E. Kennedy
Southwest Native American Collection
Kennedy Museum of Art
Ohio University
KMA 91.023.121

The designs were very simple. They were fairly plain. . . . It wasn't very intricate. That's what I remember weaving. But today, a lot of the designs are very intricate. The designs are very elaborate. I remember people used to make large ones. That's what I remember. That's what my mother and my grandmother wove.

— Grace Henderson Nez

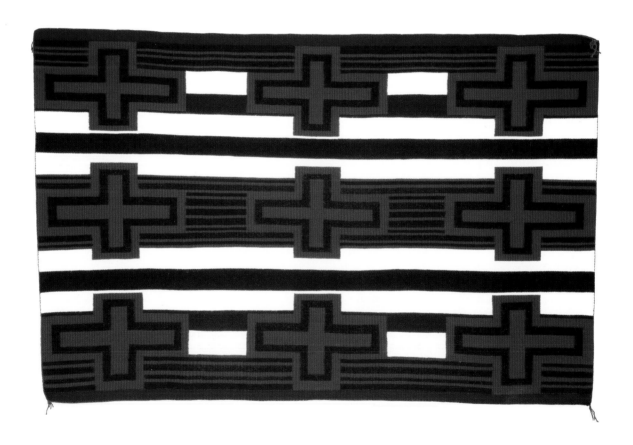

Plate 2

Mary Henderson Begay
Ganado Double Cross, 1980
natural (undyed) and aniline-dyed
commercial wool
49 x 72.5 in.
Edwin L. and Ruth E. Kennedy
Southwest Native American Collection
Kennedy Museum of Art
Ohio University
KMA 91.023.293

I went out with the sheep, took care of them. My mother told me to take the spindle with me so I could practice, and I took the spindle with me, and that's where I learned how to spin by practicing, practicing while I was herding sheep. I also just thought of ways of improving my spinning, and that's when I became better.

— Mary Henderson Begay

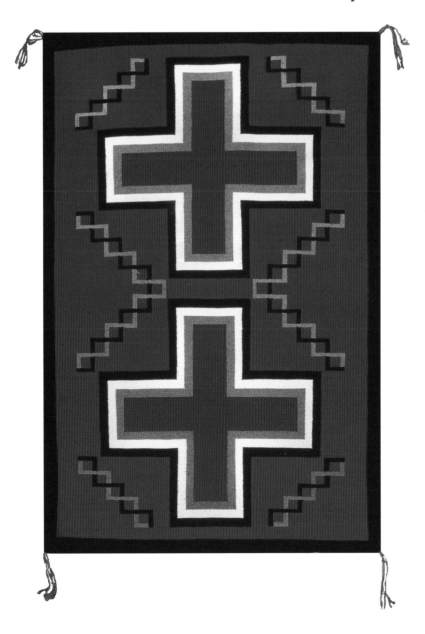

Plate 3

Mary Henderson Begay
Chief Style Blanket, 2004
natural (undyed) and aniline-dyed
commercial wool
37.5 x 49.5 in.
Edwin L. and Ruth E. Kennedy
Southwest Native American Collection
Kennedy Museum of Art
Ohio University
KMA 2004.09.01

*I feel sad for the blankets because of the significance of
the Chief Blankets, because a long time ago our people
made the Long Walk. That's why I like them, because of
how they were used and when they were used in times
of hunger, in times of imprisonment.*

—Mary Henderson Begay

I watch my niece, and she will climb on my mother's lap, and she'll play with the yarn, play with her tools. She'll play with the loom. I'm sure there's no doubt that I probably did the same thing. . . . But for me it's not play. It's never play. It never was play, and it probably will never be play for me. But I want to change that for my daughter. I want her to have fun with it because I never have fun with it. I never have fun. . . . I don't want her to be like me. I don't want her to look at it as a chore. I want her to have fun. I want her to want to do it.

—**Gloria Jean Begay**

Plate 4

Gloria Jean Begay
Dawn Meets Dusk, 2005
natural (undyed) and aniline-dyed
commercial wool
48 x 59 in.
Edwin L. and Ruth E. Kennedy
Southwest Native American Collection
Kennedy Museum of Art
Ohio University
KMA 2005.06.01

I learned by my mother. I know my mother has been gone for a long time, and I know that I learned from my mother, and I think about that, and I'm thankful for that, too. I know she has passed on, but her teaching continues to be with me today even though I'm very old.

—Glenabah Hardy

Plate 5

Glenabah Hardy
Crystal Wall Hanging, 1983
vegetal-dyed commercial wool
43.75 x 60.5 in.
Edwin L. and Ruth E. Kennedy
Southwest Native American Collection
Kennedy Museum of Art
Ohio University
KMA 91.023.107

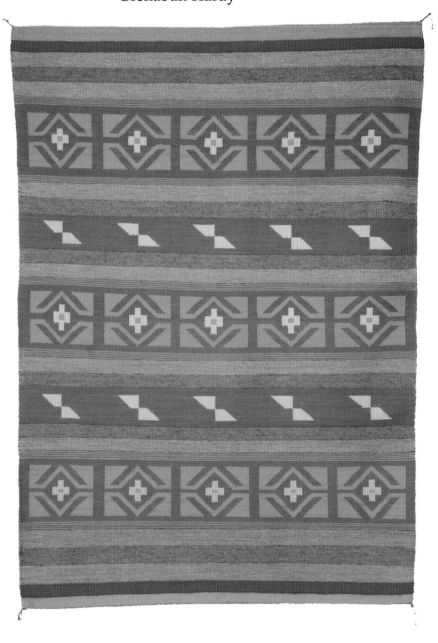

Your design really just involves your thinking. It's all how you think about your design.

—Glenabah Hardy

Plate 6

Glenabah Hardy
Crystal Wall Hanging, 1980
vegetal-dyed commercial wool
42 x 56 in.
Edwin L. and Ruth E. Kennedy
Southwest Native American Collection
Kennedy Museum of Art
Ohio University
KMA 91.023.296

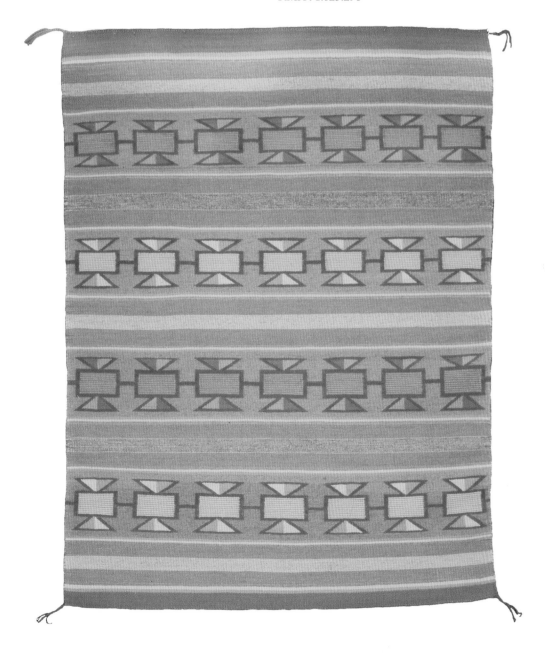

This is what you call iina' *(life). It is life, it provides many good things, it has money, good food. Weaving gives you good things. This is what it is.*

— Irene Clark

Plate 7

Irene Clark
Crystal Wall Hanging, 1979
vegetal-dyed commercial wool
72 x 49 in.
Edwin L. and Ruth E. Kennedy
Southwest Native American Collection
Kennedy Museum of Art
Ohio University
KMA 91.023.78

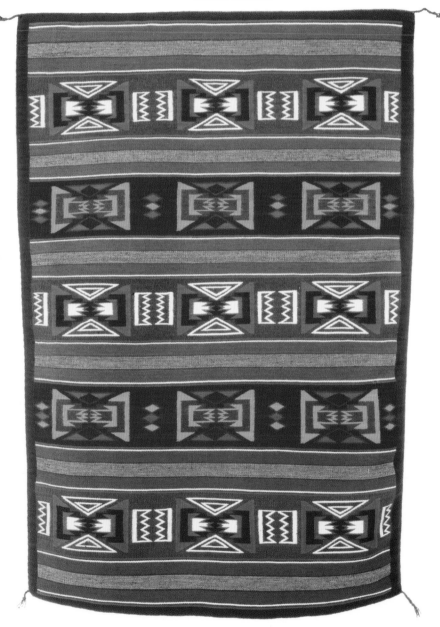

Sometimes I see a design and I use that idea, but when you create a design, it lends itself to creativity. It makes you think. Yes, our designs are our thinking. That's our life. It makes us think. . . . The spirit line is what we're talking about—the way out. But my weaving has a lot of openness because my design is horizontal. My weaving is borderless, and it's all open. My spirits are open.

— **Irene Clark**

Plate 8

Irene Clark
Crystal Wall Hanging, 2005
vegetal-dyed commercial wool
48 x 72 in.
Edwin L. and Ruth E. Kennedy
Southwest Native American Collection
Kennedy Museum of Art
Ohio University
KMA 2005.05.01

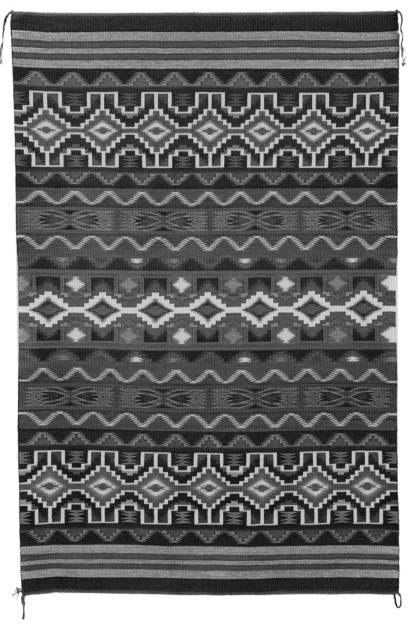

Plate 9

Teresa Clark
Crystal Wall Hanging, 2005
vegetal-dyed commercial wool
56 x 48.5 in.
Edwin L. and Ruth E. Kennedy
Southwest Native American Collection
Kennedy Museum of Art
Ohio University
KMA 2005.04.01

I'm very grateful and appreciative that I've learned it, and I know I need to put more time into it. When I do weave, it's from my heart and it's a good feeling. It's time when I can think. Like my Mom said, it's really your identity. What goes into it is who you really are and how you were brought up, and that's how I feel when I weave. So I'm very grateful that they've learned it and they've passed it on. And I'm going to do what I can to pass it on to the grandkids, the granddaughters.

— **Teresa Clark**

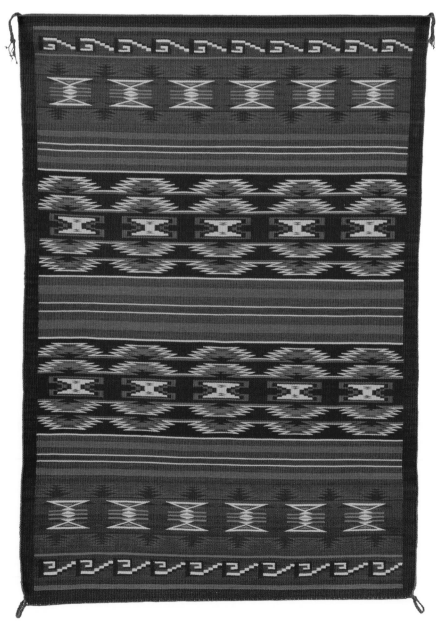

When I was young, I wanted to weave, and today my granddaughters are the same. They want to weave and they are interested in weaving. They enjoy it, and they say that they want to do it. They want to weave. . . . The way of life needs to continue, and that is how I perceive it And in my home and in my life here, I want my children to continue this weaving. This is what I want them to do, and this is what I am happy about.

— Lillie Taylor

Plate 10

Lillie Taylor
Two Grey Hills Double Pattern, 1980
natural (undyed) and aniline-dyed
commercial wool
70.5 x 71.75 in.
Edwin L. and Ruth E. Kennedy
Southwest Native American Collection
Kennedy Museum of Art
Ohio University
KMA 91.023.317

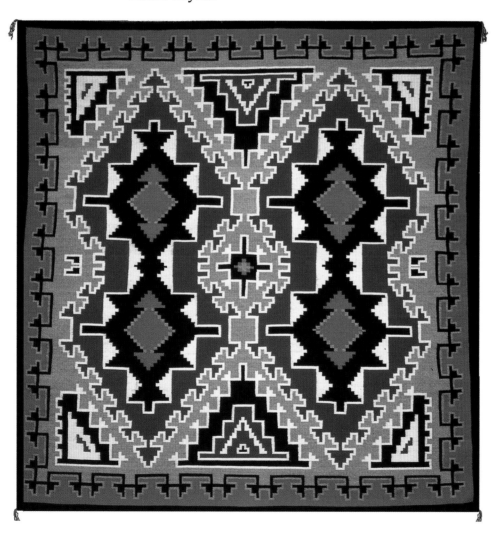

Plate 11

Lillie Taylor
Multi-Pattern Four-in-One, c. 1975
natural (undyed) and vegetal-dyed
handspun wool
69.5 x 71.75 in.
Edwin L. and Ruth E. Kennedy
Southwest Native American Collection,
Kennedy Museum of Art
Ohio University
KMA 91.023.374

You think of your children and, in return, they will also remember you. I believe it is the same with the weavings. I am remembered. It will make me feel good.

— **Lillie Taylor**

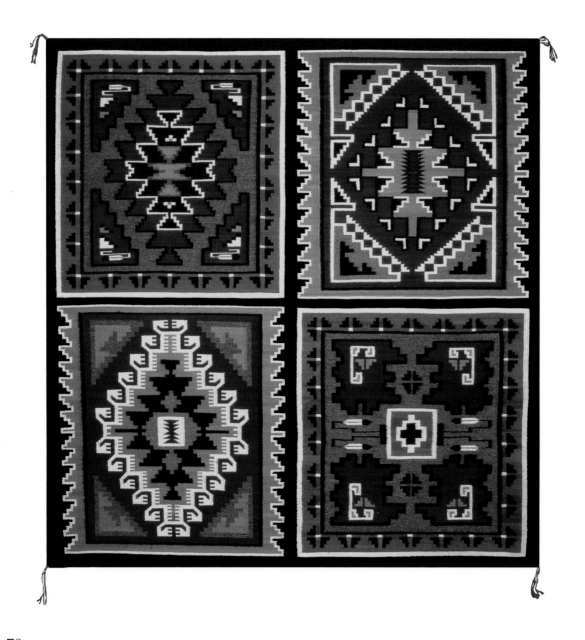

70

I like my work very much, even though it involves a lot of hard work. Weaving is like your mother. My mother is old, but I feel that my mother is here. I wake up healthy each day in my home. I wake up and perform my daily prayers. I pray for my home to be good. That is how I live here.

— **Lillie Taylor**

Plate 12

Lillie Taylor
In the Path of the Four Seasons, 2004
natural (undyed), vegetal-dyed and aniline-dyed handspun wool
31 x 48 in.
Edwin L. and Ruth E. Kennedy
Southwest Native American Collection
Kennedy Museum of Art
Ohio University
KMA 2004.08.01

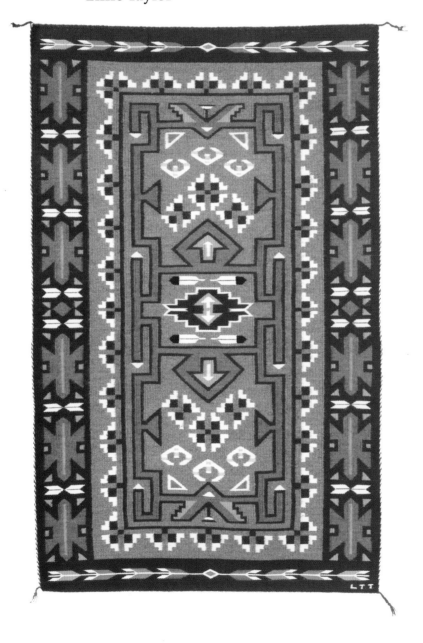

When I was a young girl, I used to watch my mother weave.
I used to stand behind the loom and look at her through the
warps. That's where I stood and watched her. Sometimes
I used to put my finger through the warps, and she would
pick up her comb and push my fingers away. That's what
I remember a long time ago. . . . She has probably been
the most influential person in my life. She taught me the
stories, my culture, about weaving, the stories behind the
weaving, the inspiration, the story about Spider Woman
and what inspires her to
weave.

— **Diane Taylor Beall**

Plate 13

Diane Taylor Beall
In Honor of a Medicine Man
(Two Point Canyon Rug), 2004
natural (undyed), aniline-dyed, and
vegetal-dyed commercial wool
32 x 30 in.
Edwin L. and Ruth E. Kennedy
Southwest Native American Collection
Kennedy Museum of Art
Ohio University
KMA 2004.19.01

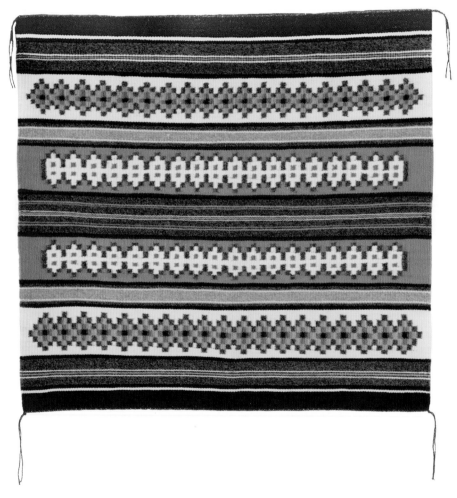

Plate 14

Rosie Taylor
Family Teaching, 2004
natural (undyed), vegetal-dyed, and
aniline-dyed handspun wool
37 x 24.5 in.
Edwin L. and Ruth E. Kennedy
Southwest Native American Collection,
Kennedy Museum of Art,
Ohio University
KMA 2004.18.01

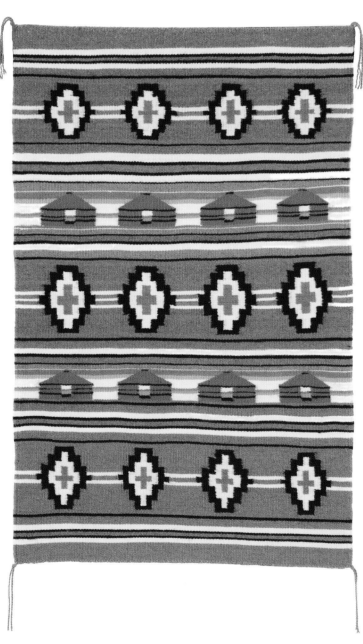

Patience and probably culture. Those are the teachings. They tell you a story about weaving as you progress along. They don't tell you everything at one time. So, along the way, a couple of years down the road, I tell them a different story about weaving, maybe prayers about weaving, songs about weaving. I don't just pound it into their heads when they're small. It takes time to tell all of them—to sink in. Because I think that's how my mom taught me. Every now and then she'll give me point- ers, even at this stage. She still gives me pointers about where to make these changes. So I still get a lot of pointers from my mom, a lot of stories. And every now and then, she'll tell me a song, which is really a nice thing to have.

— **Rosie Taylor**

73

Plate 15

Amber and Twyla Gene
Untitled, 2004
natural (undyed), vegetal-dyed, and aniline-dyed
handspun wool
28.5 x 20 in.
Edwin L. and Ruth E. Kennedy
Southwest Native American Collection
Kennedy Museum of Art,
Ohio University
KMA 2004.10.01

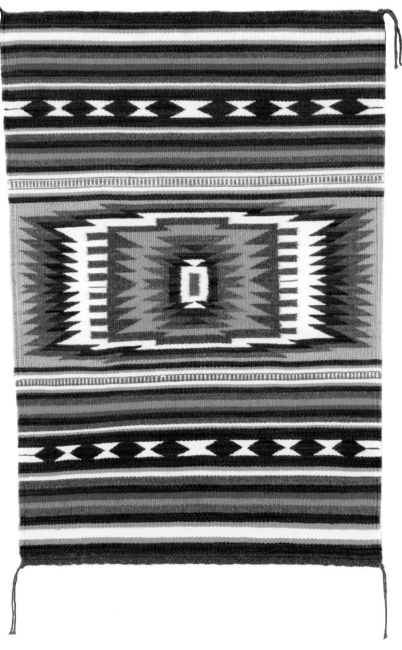

Plate 16

D. Y. Begay
Cheyenne Style, 2002
natural (undyed) and vegetal-dyed
handspun wool
25.5 x 35.75 in.
Edwin L. and Ruth E. Kennedy
Southwest Native American Collection
Kennedy Museum of Art
Ohio University
KMA 2004.05.01

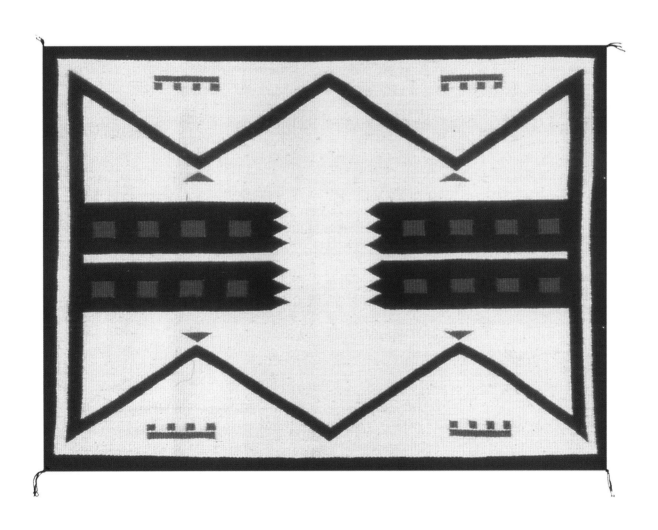

Plate 17

D. Y. Begay
Child's Manta, 2004
natural (undyed) and vegetal-dyed handspun wool
47 x 26 in.
Edwin L. and Ruth E. Kennedy
Southwest Native American Collection
Kennedy Museum of Art
Ohio University
KMA 2004.17.01

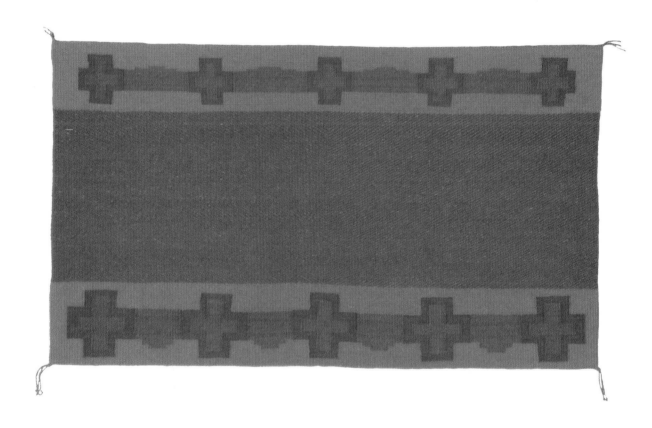

Plate 18

D. Y. Begay
Unexpected Inspiration, 2004
natural (undyed) and vegetal-dyed
handspun wool
27 x 48.5 in.
Collection of the artist

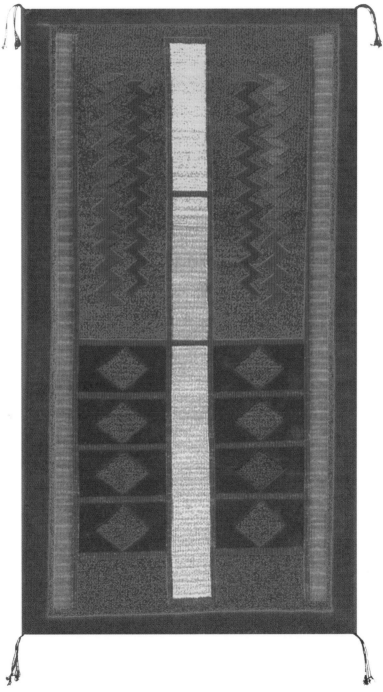

Plate 19

D. Y. Begay
Two Points, 2005
natural (undyed) handspun wool
60 x 36 in.
Collection of the artist

Bibliography

Begay, D. Y. "A Weaver's Point of View." In *All Roads are Good: Native Voices on Life and Culture*, edited by W. Richard West. Washington, D.C.: Smithsonian Institution Press in association with the National Museum of the American Indian, Smithsonian Institution, 1994.

Begay, D. Y. *Another Phase: Weaving by D.Y. Begay*. Santa Fe: Wheelwright Museum of the American Indian, 2003.

Begay, D. Y. "*Shi' sha' hane'* (My Story)." In *Woven by the Grandmothers*, edited by Eulalie Bonar. Washington, D.C.: Smithsonian Institution Press, 1996.

Berlo, Janet. "Beyond *Bricolage*: Women and Aesthetic Strategies in Latin American Textiles." In *Textile Traditions of Mesoamerica and the Andes*, Margot Schevill, Janet Berlo and Edward Dwyer. Austin: University of Texas Press, 1996.

Dedera, Don. *Navajo Rugs: How to Find, Evaluate, Buy, and Care for Them*. Flagstaff: Northland Press, 1975.

Dockstader, Frederick J. *Song of the Loom: New Traditions in Navajo Weaving*. New York: Hudson Hills Press in association with the Montclair Art Museum, 1987.

Hedlund, Ann Lane. "Give-and-Take: Navajo Grandmothers and the Role of Craftsmanship." In *American Indian Grandmothers: Traditions and Transitions*, edited by Marjorie M. Schweitzer. Albuquerque: University of New Mexico Press, 1999.

———. *Navajo Weaving in the Late Twentieth Century: Kin, Community, and Collectors*. Tucson: University of Arizona Press, 2004.

———. *Reflections of the Weaver's World: The Gloria F. Ross Collection of Contemporary Navajo Weaving*. Denver, Colo.: Denver Art Museum; distributed by the University of Washington Press, 1992.

Kaufman, Alice and Christopher Selser. *The Navajo Weaving Tradition: 1650 to the Present*. New York: Dutton, 1985.

Kent, Kate Peck. *Navajo Weaving: Three Centuries of Change*. Santa Fe, N.M.: School of American Research Press; distributed by University of Washington Press, 1985.

McLerran, Jennifer. "Woven Chantways: The Red Rock Revival." *American Indian Art Magazine* 28, no. 1 (Winter 2002): 64-73.

Rodee, Marian, and Maxwell Museum of Anthropology. *Southwestern Weaving*. Albuquerque: University of New Mexico Press, 1977.

———. *Weaving of the Southwest*. West Chester, Penn.: Schiffer Publishing, 1987.

Schwarz, Maureen Trudelle. "The *Biil*: Traditional Navajo Female Attire as Metaphor of Navajo Aesthetic Organization." *Dress* 20 (1994): 75-81.

———. *Molded in the Image of Changing Woman: Navajo Views on the Human Body and Personhood*. Tucson: University of Arizona Press, 1997.

Wheat, Joe Ben. *Blanket Weaving in the Southwest*. Edited by Ann Lane Hedlund. Tucson: University of Arizona Press, 2003.

Whitaker, Kathleen. *Southwest Textiles: Weavings of the Navajo and Pueblo*. Los Angeles, Southwest Museum in association with the University of Washington Press, 2002.

Witherspoon, Gary, and Glen Peterson. *Dynamic Symmetry and Holistic Asymmetry in Navajo and Western Art and Cosmology*. New York: Peter Lang, 1995.